Garden of Mirrored Flowers

Garden of Mirrored Flowers

Hu Fang

Translated by Melissa Lim

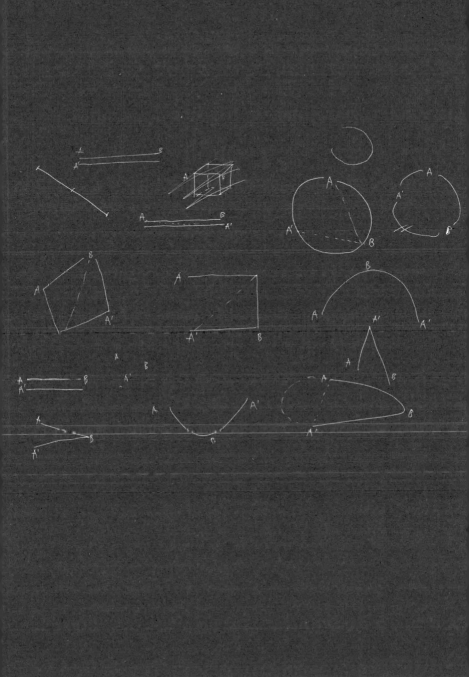

Contents

In this way, their lives were experiencing almost imperceptible changes every day.

A: Garden of Mirrored Flowers

Entrance 1

Collection. He had a distinct feeling that this phrase was still inadequate, and as such, tried to append something to it:

Co-collection. Or co-co-co-collection,

Co-collection—collection. This strange and tongue-twisting derivative finally became the brand name of his design company.

Through this derivative, he drew a sense of kinetic energy to propel himself further and further away from his source, which granted him the right to enter this world: if collections imply the demise of time as well as that of inheritance, then the prefix co-, as used in the name of this child-like entity that adults have striven to create, would be an opportunity for active

collections. If we regard the passion in building contemporary collections as a sort of game with time—one dealing with legacies of families, cultures, countries, histories, the world; in the end, all these must be transformed into legacies of the market—then we should hardly be surprised that within this game, the present era is often shrouded by a sense of emotional hurt and hysteria. It is as if this wordplay has attempted to issue a bold declaration: co- (i.e., "co-activates collections, co-increases the value of time.")

Therefore, the mythology of materialism unfolding before our eyes has a sort of historical value, and it has adequately concealed the truth about our lack of a mythology of origins as well as the atrophy of our collective consciousness: "We are forever collecting ourselves."[1]

1. Jean Baudrillard, *Le Système des Objets*, Chinese edition, trans. Lin Zhi Ming, (Shanghai People's Publishing Company, Century Publishing Group, 2001), 105.

cocollection

www.cocollection.de

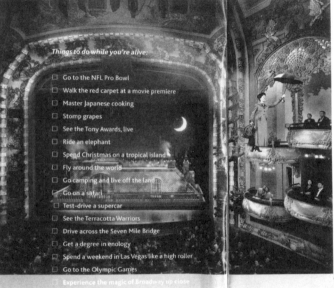

Things to do while you're alive:

- ☐ Go to the NFL Pro Bowl
- ☐ Walk the red carpet at a movie premiere
- ☐ Master Japanese cooking
- ☐ Stomp grapes
- ☐ See the Tony Awards, live
- ☐ Ride an elephant
- ☐ Spend Christmas on a tropical island
- ☐ Fly around the world
- ☐ Go camping and live off the land
- ☐ Go on a safari
- ☐ Test-drive a supercar
- ☐ See the Terracotta Warriors
- ☐ Drive across the Seven Mile Bridge
- ☐ Get a degree in enology
- ☐ Spend a weekend in Las Vegas like a high roller
- ☐ Go to the Olympic Games
- ☐ Experience the magic of Broadway up close

Whatever's on your list of things to do in life, do it better with Visa Signature. With preferred seating at Broadway shows like Mary Poppins, it takes you places regular rewards cards can't, in a most delightful way.

LIFE
TAKES
VISA

VISA ∫IGNATURE

Presenting Visa's line of luxury rewards cards. Benefits
beyond rewards. Dozens of card choices Visa.com/signature

14

Entrance 2:

Things to do while you're alive:

* Go to the NFL Pro Bowl
* Walk the red carpet at a movie premiere
* Master Japanese cooking
* Stomp grapes
* See the Tony Awards live
* Ride an elephant
* Spend Christmas on a tropical island
* Fly around the world
* Go camping and live off the land
* Go on a safari
* Test-drive a supercar
* See the Terracotta Warriors
* Drive across the Seven Mile Bridge
* Get a degree in enology
* Spend a weekend in Las Vegas like a high roller
* Go to the Olympic Games
* Experience the magic of Broadway up close

僕は、夢に生きる。

星になった少年
Shining Boy & Little Randy

Wiener **W** Festwochen Wiener **W** Festwochen

HAUPTSPONSOR DER WIENER FESTWOCHEN **A1**

Halle G im MuseumsQuartier

Museumsplatz 1
1070 Wien

The World in Pictures
Forced Entertainment

Samstag, 3.6.06 20:30 Uhr

20,00 EUR Inkl. 10% USt

Halle G im MuseumsQuartier
The World in Pictures
03.06.2006

TRIBÜNE LINKS
Reihe 8
Platz 4

TRIBÜNE LINKS
Reihe 8 Platz 4

1-d100-106974-6-1-1

Bitte Rückseite beachten.

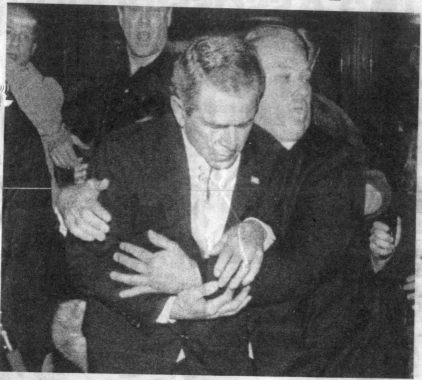

thelondonpaper

www.thelondonpaper.com / MONDAY 9 OCTOBER 2006

GEORGE W. BUSH
6 JULY 1946 – TONIGHT 9PM

168. Next, we need to balance the gains and losses of struggles and death against the forfeit of freedom and dignity. To most of us, freedom and dignity rank much higher in importance than longevity and the avoidance of physical trauma. Furthermore, we will have to die sooner or later. To die as a result of fighting for one's life or for some other cause is much better than a hollow life with no meaning and goal.[2]

2. Theodore Kaczynski (who committed a series of mail bombings as the Unabomber), *Industrial Society and Its Future* (or *The Unabomber Manifesto*), selected from Liu Huai Zhao and Wang Xiao Dong, *Civilised Bombing* (China Cultural and Historical Publishing, 1996), 232-33.

Awake!

MAY 2007

Coping in a World
of unequal opportunities

ALSO: IS YOUR LIFE
PREDESTINED? **PAGE 12**

5 minutes from Disneyland!

Visit the world famous

CRYSTAL CATHEDRAL

The home of world-class architecture, the *Hour of Power* television service, and the friendliest congregation you'll ever find!

After the political upheavel of the 1960s, the USA has completely retreated into absolute navel-gazing and self-obsession. Because there is no hope for any substantive improvement in life, people began to believe that what is truly important is the perfection of the individual on a psychological and spiritual level: they developed an interest in their consciousness and emotions, health food products and produce, learned ballet or belly-dancing, immersed themselves in Eastern philosophies, jogged, took an interest in developing "positive social interactive skills," tried to overcome their "fear of happiness"... Our current mood is one geared towards treatment and is completely secular in orientation. [3]

3. Christopher Lasch, *The Culture of Narcissism*, Chinese edition, trans. Chen Hong Xia and Lu Ming (Shanghai Cultural Publishing Company, 1988), 3, 5.

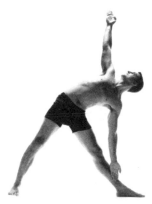

23

theresia@hotmail.com

body work

imagery exercises イメージ

📱 |0043| 0699 1318 9522

導引
do in

REFINING BATH LILY
Use with Shower Gel for rich, creamy
lather and light exfoliation.

NÉNUPHAR POUR LE
BAIN PURE DOUCEUR
À utiliser avec votre Gel Douche pour
une mousse riche et onctueuse et une
exfoliation tout en douceur.

Fotos › **Stefan Korte** Styling › **Vesna Barisic** Models › **Arno, Bini, Esther, Jule, Julia, Lydia, Maike, Naira, Nick, Tanja** Danke an › **Axel Binder und Zeynep Yücel**

:BEWEGUNG
:ERNÄHRUNG
:ENTSPANNUNG

:WIMPERNTUSCHE

KLEINER PREIS

Nivea, Volume Nano Definition, Sorgt für Schwung und Volumen, ist leicht aufzutragen und haltbar. Mit Wasser einfach zu entfernen; ca. 9,99 Euro

SINGLE-GLÜCK

Wet'n wild H₂O Lash Revolution. Volumen, Schwung oder gar Revolution? Eher nicht! Färbt aber jede Wimper schön einzeln. Wasserfest; ca. 4,49 Euro

MASCARA MIT VIBRATOR

Lancôme, Oscillation. Ein Motor sorgt für die Zickzackbewegung beim Auftragen. Verlängert, verdichtet, hält gut, verklebt aber ein bisschen; ca. 33 Euro

GUTES DARF AUCH KOSTEN

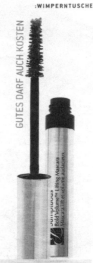

Estée Lauder, Bold Volume Lifting Mascara. Verdichtet, verlängert, gibt Schwung, hält und geht mit warmem Wasser ab. Was will Frau mehr? Etwa 19,50 Euro

MAL MIT KUGEL TUSCHEN

Givenchy, Phenomen' Eyes. Runde Bürste schwierig zu handhaben. Präzises Auftragen ist Pflicht. Wenig Verdichtung, wenig Schwung; ca. 26 Euro

FÜR NATURMÄDELS

Dr. Hauschka, Volume Mascara. Naturkosmetik für die Wimpern. Trennt schön, verdichtet, lässt sich leicht abnehmen. Hält einen Vormittag; ca. 15 Euro

PERFEKT UND GÜNSTIG

Maybelline Jade, Volume & Define. Volumen, Haftung, Wimperntrennung, Schwung, Dichte – perfekt! Abschminken etwas heikel; ca. 11 Euro

VOLUMENBRINGER

L'Oréal, Extra Volume Colagen. Verlängert und sieht natürlich aus. Lässt sich gut auftragen und leicht entfernen. Hält auch beim Augenreiben; ca. 14 Euro

AMY CLEANING

AND IRONING

We provide cleaners who are:

✓ Carefully vetted and monitored

✓ Friendly, honest and reliable

✓ Local, and you can have the same person each time

✓ Insured

✓ Outstanding value

Local call rates
0845 062 9999
or order online at
www.amycleaning.co.uk

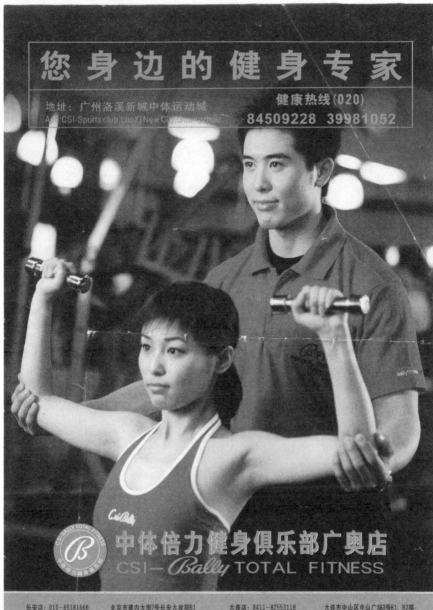

The Fitness Expert by Your Side

Singapore Indoor Golf: Instruction Manual

...to Changi Airport. Putt your way through before leaving the plane.
...机场。...
...datang ke Lapangan Terbang Changi. Masukkan bola anda di...

②
At the Discovery Centre, check out the submarine, fighter plane and tank.
在发现中心，...
Cubalah kapal selam, kapal terbang dan tank ... lawati Discovery Centre.

③
Try your luck at the Turf Club, you may just be a winner.
...赛马俱乐部...
Cubalah nasib anda di Turf Club, anda mungkin pemenang.

...any or musical, take your pick at the Esplanade.
...或喜欢，可以到海艺术中心尽情选择。
...atau muzikal, buatlah pilihan anda di Esplanade.

⑤
MRT's North-South, East-West lines will get you there.
地铁南北线、东西线将把您带到那里。
Gunakan MRT Utara-Selatan atau Timur-Barat ke mana-mana yang dingini.
MRTの南北、東西線がここにお連れします。

⑥
Will your putting skill through the Fountain of Wealth brin...
以您击球的技术，"财富之泉"会给您带来财富吗？
Adakah "Fountain of Wealth" akan membawa anda tua...

...ball has arrived in a container at Singapore Port.
已经到达了新加坡港的集装箱里。
...da telah sampai dalam kontena di Singapore Port.
シンガポール港のコンテナに着きました。

⑧
Try Satay, Chicken Rice and other local favourites at the Food Centre.
在美食中心尝尝沙嗲、鸡饭和其它地方小吃。
Cubalah Satay, Nasi Ayam dan lain-lain makanan tempatan di Pusat Makanan.
フードコードでサテー、チキンライス、又は美味しい地元料理をお試しください。

⑨
Welcome to LilliPutt, putt carefully and watch out for...
欢迎来到LilliPutt，小心击球，...
Selamat Datang ke LilliPutt, berhati-hati mengelak selok-b...
リリパットへようこそ！慎重に気をつけてパットしてください。

...ar Villa, the Buddha is laughing, why? Because of the previous putt!
...佛祖含笑，笑什么？笑你的前一杆击球啊！
...patung berhala Buddha di Haw Par Villa bersenyum kerana pukulan ...nya ini!
...ビラではさっきのパットをして仏陀が笑っています。

⑪
Learn putting and physics at Science Centre! Try ski-putting at Snow City!
在科学馆学习击球和物理知识！在雪地试试雪橇式打球吧！
Pelajari bermain golf dan fiziks di Science Centre! Cuba memukul sambil bermain ski di Snow City!
サイエンスセンターで物理学を学び、スノー・シティではスキー・パットに挑戦。

Careful, don't feed your ball to the animals at the Zoo, you migh...
小心，别把您的球喂给动物园里的动物，那可有去无回...
Anda mungkin tidak akan dapatkan bola anda balik jika dimak...
動物園では動物にボールを与えないでください。返してくれない...

...Padang for a quick ride in a Trishaw. Anyone for Cricket or Rugby?
...场乘三轮车游览一番，有人对板球或橄榄球感兴趣吗？
...eca di Padang. Ingin bermain Kriket atau Ragbi?
...乗り返してトライショに乗ってみましょう。クリケット又はラグビーはいかが でしょうか？

⑭
Experience Boat Quay, Singapore's famous riverside entertainment hub.
体验驳船码头。新加坡最著名的河畔娱乐中心。
Lawati Boat Quay, pusat hiburan tepi sungai Singapura yang terkenal.
シンガポールの有名な川沿いのエンターテイメントの中心、ボート・キーに行ってみましょう。

⑮
If bird watching is your thing, check out the flamingos at...
假如您喜欢观察鸟类，可以在飞禽公园看看红鹤。
Dekatilah burung flamingo di Bird Park.
バードウォッチングがお好きであればバードパークでフラミンゴを...

...cable car to Mount Faber and hope your ball comes out the right exit!
...缆车。希望你的球能找到正确的出口？
...eta kabel ke Mount Faber dan harap ia keluar dari tempat yang betul!
...ウェーバーでケーブルカーに乗りみんで、ボールが正しい出口から出ることを願っています。

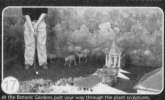

At the Botanic Gardens putt your way through the plant sculptures.
在植物园里让您的球穿过各种各样植物的雕塑。
Di Botanic Gardens, pukulan bola antara ukiran-ukiran tumbuhan.
ボタニック・ガーデンでは植物の彫刻をゆっくり通り抜けましょう。

Round off your visit to LilliPutt at Sentosa, Merlion and the M...
在圣陶沙岛的鱼尾狮雕像和音乐喷泉中完成您的LilliPutt之...
Akhiri lawatan anda di Sentosa, Merlion dan Musical Fou...
マーライオン、ミュージカル・ファウンテンでセントーサのリリパットの...

SINGAPORE

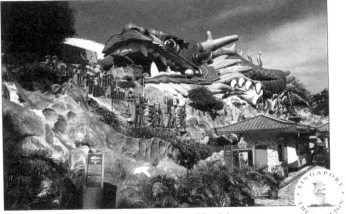

Haw Par Villa, created by the founders of Tiger Balm.

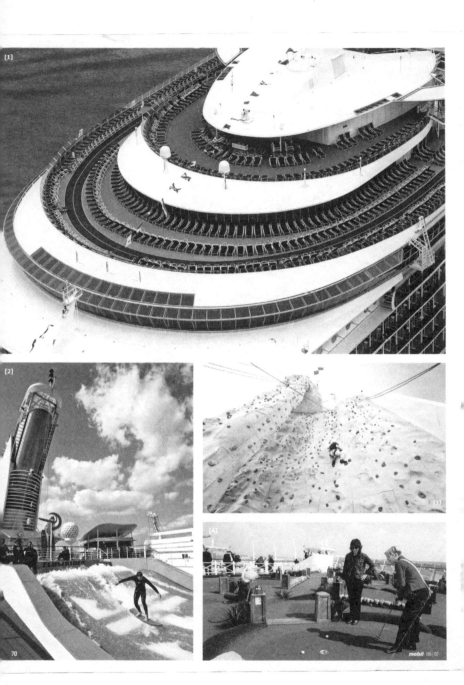

70

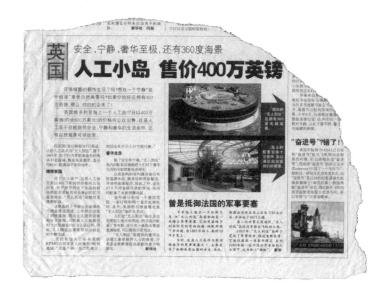

Safe, serene, incredibly opulent, with a 360-degree seaview

BRITISH MANMADE ISLAND SOLD FOR 400 MILLION BRITISH POUNDS

In einer Tiefe von 15 Meter unter Wasser sollen die Gäste tanzen oder durch eine gläserne Kuppel, die aus dem Meer ragt, in der Sternenhimmel schauen – so plant ein deutsches Unternehmen das Hotel Hydropolis. In a bedroom 15 metres down, guests at the Hydropolis hotel will be able to dance or gaze at the stars through a glass dome that extends out of the water – at least that's what one German businessman is planning

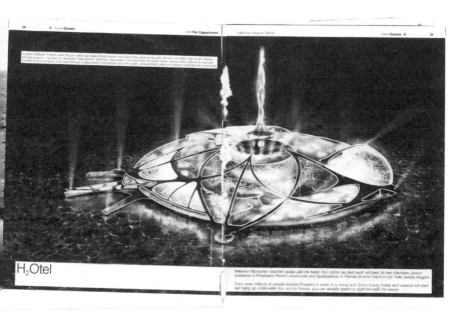

H₂Otel

Millionen Menschen tauchen jedes Jahr ins Meer. Nun sollen sie dort auch wohnen. In den nächsten Jahren entstehen in Poseidons Reich Luxushotels und Spielcasinos. In Florida ist eine Nacht in der Tiefe bereits möglich

Every year, millions of people explore Poseidon's realm in a diving suit. Soon, luxury hotels and casinos will start springing up underwater, too, and in Florida, you can already spend a night beneath the waves

𝖂eekly 🌐 𝖕lanet

FPNYC

All the news that is forbidden. **#71** Wednesday, December 12th 2007

Your Planet, Welcome
By Jeff Ayers

There's mad heads- to use the parlance of our times- in the store this Holiday Season, a great many of you I've never encountered, and many of you from such kooky exotic places as "Long Island" and "New Zealand." Terrific. Welcome to New York City and Forbidden Planet. I'm the store manager, Jeff Ayers. Nice to meetcha. Let's talk about books, shall we?

This Week's Hugo Winning Novel?

A Fire Upon the Deep- by **Vernor Vinge**. We've been doing this reading club kinda thing in these pages for a few weeks now, wherein we (try to) read a novel that has won

Science Fiction's top honor every seven days. I have never read this book before; but it takes a certain fortitude to try something new and take the brave plunge into the plasma pool, and we are chock full of that!

Releasing 12/12/07

Green Lantern #25- "The Sinestro Corps War," concludes in this double-sized anniversary issue. And here's what DC says the issue has in store: "Why does Sinestro believe he has won? How will Hal Jordan stop his greatest enemy? What is the truth behind the prophecy of "The Blackest Night"? Where will the end results of this battle take the Green Lantern Corps? What is the bizarre fate of the Anti-Monitor? Why has Earth been assigned so many Green Lanterns? Learn all the secrets! Witness all the battles!

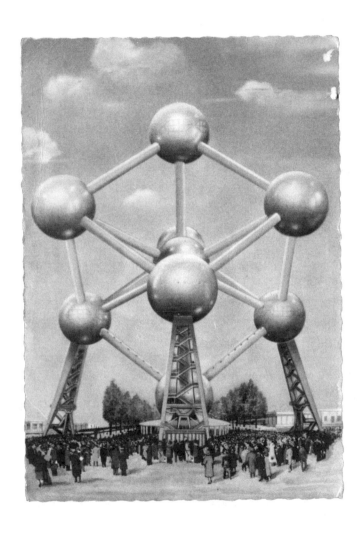

Unlike traditional games, you do not need to move up levels in the Sims, nor do you need to accumulate experience to play it: there is no victory nor defeat; in fact, there isn't even an ending. Upon entering the game, you will first need to create an avatar, or you can choose to create a few to make an entire simulated family. You can design your characters based on real-life situations: for instance, you can name the avatar after yourself, and outfit it with a personality, skin color, hairstyle and clothing similar to yours. The game furnishes a lot of detailed information to assist you in recreating yourself or someone you are interested in as realistically as possible.

On the official Sims website, thousands of players have written and uploaded novels based on the lives of avatars they have created. Most of these stories have plots, dialogue, and even still shots and screen captures from the game. A typical example of such a novel would usually contain tens of thousands of words and one or two hundred pictures. If you read these novels, you would discover that most mirror the real lives of people. You could even say that these texts collectively depict the contemporary life of humankind.

Die Sims haben ein Herz für Tiere

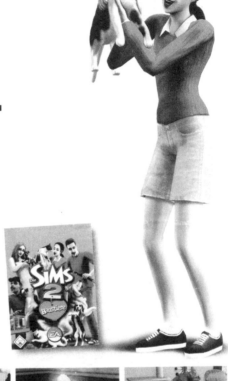

Bei **DIE SIMS 2 HAUSTIERE** sind Hunde, Katzen, Vögel und Meerschweinchen mit im Spiel.

VIELFALT ist bei DIE SIMS 2 HAUSTIERE oberstes Gebot. ...o kannst du aus einem Dutzend ...erschiedener Hunde- und ...tzenrassen wählen oder dir ...ar ein einzigartiges neues ...stier mit eigener Persönlichkeit ...'ren. Natürlich ist dein Sim wie ...hren Leben als Besitzer für ...ege und die Erziehung ...'Tieres verantwortlich.

FÜR DIE PC SIMS2 SPIELER das neue, tierische Spielerlebnis. Jetzt sind deine Sims nicht mehr die Einzigen, die Karriere machen! Geschickte Haustiere können sich dank drei verschiedener Karriere-Laufbahnen im Show-Business, in der Sicherheitsbranche und im Dienstleistungsgewerbe ihren Lebensunterhalt selbst verdienen und sich durch fünf Job-Level nach oben arbeiten.

FÜR NINTENDO GAMECUBE & PS2: Deine Sims können mit ihren Haustieren den Stadtpark besuchen, wo sie mit ihren pelzigen Freunden spielen und andere Sims und ihre Tiere treffen. Kaufe deinen Tieren lustige Gegenstände in den Geschäften der Stadt und sieh zu, wie das Stadtzentrum mehr und mehr wächst.

FÜR GAMEBOY ADVANCE, NINTENDO DS UND PSP: Erstelle Sims und bestimme, wie sie ihr Leben verbringen – es liegt in deiner Hand, welche Geschichten sie erleben. Aber eines solltest du nie vergessen: Auch Haustiere haben ihren eigenen Kopf. Erwarte das Unerwartete!

白俄罗斯学生实地考察旅行如此教育

送年轻人入狱体验生活

他们被带进监狱，受到囚犯一样的待遇，被毒打、羞辱。但他们并没有犯罪，也不是疑犯，他们只是白俄罗斯的一群学生

本报综合报道 近日，白俄罗斯城市博布鲁伊斯克一群参加实地考察旅行的学生被带到当地一家少年犯管教所，以亲身感受犯罪的严重后果。他们被当作真正的罪犯，受到了非人的待遇。几名受不了侮辱的学生向警察局和媒体求助，要求惩罚带队的老师，却迟迟得不到答复。

✓体验囚犯生活

15岁的雅库本科告诉《莫斯科时报》记者，包括她在内的35名学生在领队亚历山大·格拉齐的带领下，参观一家少年犯管教所。当他们进入监狱，学生们突然发现，自己受到的待遇同真的囚犯没有两样。他们被强迫吃囚犯餐，稍稍进食的人遭到拳打脚踢。与此同时，领队格拉齐不但袖手旁观，还鼓励狱警殴打、羞辱学生。当一些囚犯向学生挑衅，偷走了他们的钱和手表，格拉齐也毫不理睬。雅库本科与其他3名学生向格拉齐抗议，被揪了出来，带到监狱的院子里，他们被强令面对墙壁，接着棍棒、拳头雨点般落在他们的背上。

离开监狱后，4人逃离了队伍，飞奔回家，他们的父母向地方警察局报了案，却没有等到下文。愤愤不平的雅库本科和同伴接受了当地媒体的采访后，地方检察官许诺展开调查。然而，什么也没有发生。4个学生转而求助于当地的一个人权组织。该组织负责人透露，这并非第一次接到类似的抗议，之前已经有许多人举报非正规学生实地考察旅行。学生们称，这次经历为"来自地狱的实地旅行"。他们认为，讨回公道的最好办法就是把领队格拉齐送进监狱，让他自己亲身体验生牢之苦。

旅行变恐怖袭击

在白俄罗斯，千奇百怪的学生实地考察旅行并不是第一次惹上官司。42岁领队的谢利勃奇克因为组织学生参加一次极其荒谬的实地考察旅行而被判处3年监禁。

去年夏天，谢利勃奇克带领当学生袭击了博布鲁伊斯克附近一个村庄，参加袭击的都是不满18岁的学生，年龄最小的只有11岁，他们都属于一个冒险与求生俱乐部。

在10名退役军人的带领下，身穿黑衣的俱乐部成员带着伪造瓦斯、气枪和仿真步枪包围了惊恐万分的村民，把他们赶到了一所学校的操场上。反抗的村民被毒打、捆绑、蒙上双眼。学生们把这些无辜的村民关押了几个小时，而他们还指望村民们能够理解，这只是"西伯利亚求生俱乐部"的一次"训练演习"。村民们显然不能理解，他们告上法庭。谢利勃奇克被控侵犯了他人的人身自由。在法庭上，谢利勃奇克满腹委屈，自己不过是想教给年轻人"爱国主义、勇气和正确的价值观"。

Belarusian student beaten and humiliated during research on site
SENDING YOUNG PEOPLE TO PRISON TO EXPERIENCE LIFE

SEX DOCTOR

Dr Catherine Hood is here to answer your most intimate sexual problems

DARE I TRY TO SEDUCE WIFE?

Dear Dr Cath

I'D like to find a way to seduce my wife all over again. We've been married for six years and enjoy a good sex life but all the spontaneity has gone. Since our baby was born she's been preoccupied – I come home from work and she barely seems to notice. How can I catch her eye again and get back some of our early passion?

IT'S too easy for a relationship to get into a comfortable rut with no time for flirting or real passion in bed. Sex is in the diary like just another task.

But that doesn't mean it can't be exciting, and you can still experience that early seductive appeal.

If you know when you're likely to have sex start fantasising in advance. Think of the build-up, the ambience in the room, what you want to do to her and what you'd like her to do to you.

Seduction is about being noticed, so spruce yourself up for her and ask her to dress up too. Book a babysitter and plan an evening when you can relax. Turn the TV off and put on music. Dim the lights and light some candles.

Don't talk about everyday issues – reminisce and get in touch with old romantic feelings. Then take her to bed early and give yourself enough time to enjoy slow and sensual love making. And don't bypass the kissing phase.

People do mirror each other's moods. So if you're seductive she should start flirting too. You'll soon be dying to get to the bedroom.

You can recapture that loving feeling

ISSUE OF THE WEEK

THE CURSE OF THE CALENDAR

PERIOD pain blights the lives of many women every month. One in 10 regularly take time off work because of the discomfort.

NORMAL PAIN

MOST women start getting period pain in their teens when their monthly bleeding starts. Usually it lasts for only the first day or two. Some months are worse than others as stress makes the pains worse.

WHAT'S THE CAUSE?

WHEN a period starts the womb contracts. Each contraction cuts off blood supply to the muscular wall of the womb, starving the muscle of oxygen and causing the release of pain-inducing chemicals.

BEATING THE PAIN

GENTLE exercise like walking, swimming or cycling can help, though you may not feel like it. A hot water bottle on your tummy can relieve symptoms too, as can painkillers like ibuprofen or paracetamol. Or you may prefer to try herbal remedies like agnus castus or evening primrose oil.

PROBLEM PAIN

SOME conditions can make your periods more painful, or suddenly

painful when they're usually not. Among them are:

● **Endometriosis:** Caused when part of the lining of the womb migrating to another part of the pelvis, causing bleeding every month in a place where the blood can't escape. This can be severe and last for several days.

● **Fibroids:** Benign growths in the wall of the womb that usually develop as a woman gets older. Fibroids can increase the pain of contractions and make your periods heavy too.

● **Pelvic inflammatory disease:** The sexually-transmitted infections chlamydia and gonorrhoea can both cause an infection in the womb – and sometimes the only symptom is bad period pain. If you get other symptoms of discharge, or suffer pain having sex, then you may need an infection check-up.

● **Ectopic pregnancy:** This occurs when a fertilised egg settles outside the womb. An ectopic pregnancy can require emergency treatment. If you start bleeding at a time when your period isn't due, are getting stomach pains and you could be pregnant, then seek help immediately.

SEX FACT

HIGH levels of the male sex hormone testosterone increase risk-taking among City wheeler-dealers. A study found higher levels on days when profits were up – but bigger risks can result in bigger mistakes too.

SEX TIP

IF you don't like your partner's natural pong when you make love why not incorporate a bath or shower into your sex play? Getting steamy together can be very arousing and make foreplay more enjoyable.

Write to Dr Cath c/o The Sex Doctor, Sunday Mirror Features, One Canada Square, Canary Wharf, London E14 5AP or email drcath@sunday-mirror.co.uk She cannot reply personally

Too fat to have a tot

Dear Dr Cath

I HAVE always been quite a big girl and I think it may be affecting my fertility. I've been trying to get pregnant for a year with no success. A friend says I could have polycystic ovaries. Could this be why I'm not getting pregnant?

OBESITY can cause a drop in fertility and irregular periods, and there is increasing evidence that being overweight increases the risks of ill-health

Tips for baby joy

when pregnant too. If you are on the large side it is important to try to lose a few pounds – but if you do have polycystic ovaries then losing weight may not be that easy.

One in 10 women have polycystic ovarian syndrome and irregular periods, acne, excess body hair and weight gain are all clues to the condition.

Women with the condition produce too much insulin which then overstimulates the ovaries so eggs aren't released every month.

See your doctor and ask to be tested. For more information visit www.verity-pcos.org.uk

Awake your five senses to Art

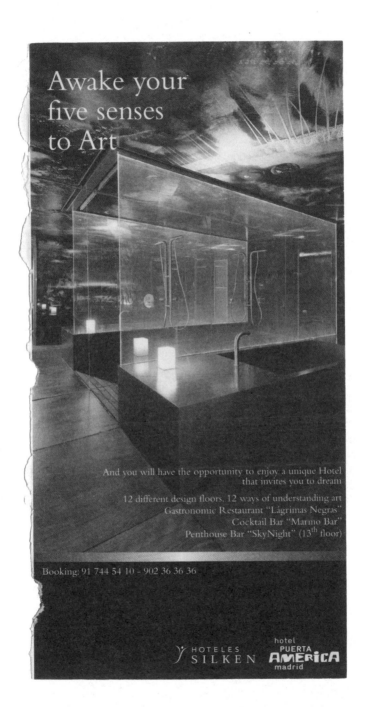

Awake your
five senses
to Art

And you will have the opportunity to enjoy a unique Hotel
that invites you to dream

12 different design floors. 12 ways of understanding art
Gastronomic Restaurant "Lágrimas Negras"
Cocktail Bar "Marmo Bar"
Penthouse Bar "SkyNight" (13th floor)

Booking: 91 744 54 10 - 902 36 36 36

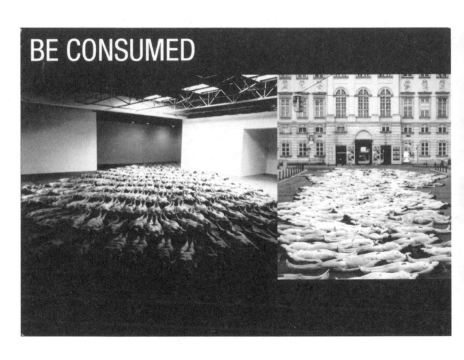

BE CONSUMED

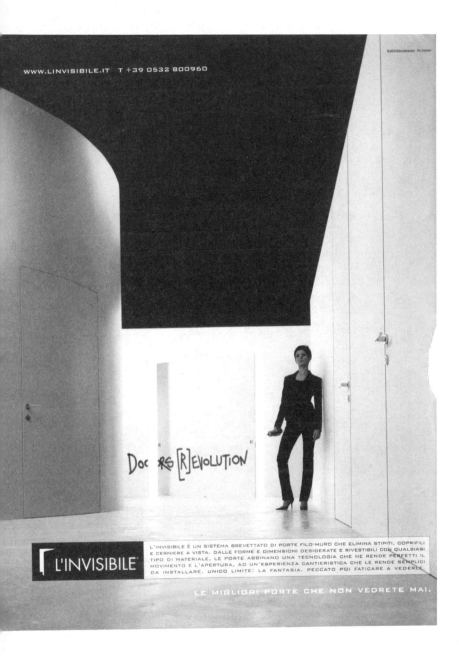

www.linvisibile.it T +39 0532 800960

Doors [R]evolution

L'INVISIBILE®

L'INVISIBILE È UN SISTEMA BREVETTATO DI PORTE FILO-MURO CHE ELIMINA STIPITI, COPRIFILI E CERNIERE A VISTA. DALLE FORME E DIMENSIONI DESIDERATE E RIVESTIBILI CON QUALSIASI TIPO DI MATERIALE, LE PORTE ABBINANO UNA TECNOLOGIA CHE NE RENDE PERFETTI IL MOVIMENTO E L'APERTURA, AD UN'ESPERIENZA CANTIERISTICA CHE LE RENDE SEMPLICI DA INSTALLARE. UNICO LIMITE: LA FANTASIA. PECCATO POI FATICARE A VEDERLE.

LE MIGLIORI PORTE CHE NON VEDRETE MAI.

World's First Chinese Success Trainer Steve Chen

DEFINITELY NO STREAKING

An amazing book that compels everyone to achieve their goals

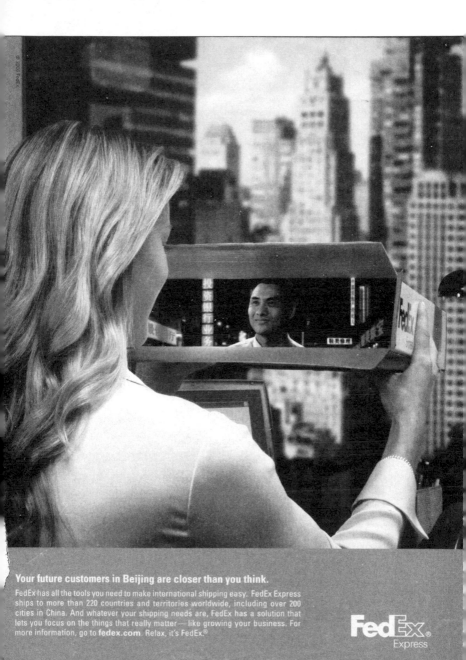

Your future customers in Beijing are closer than you think.

FedEx has all the tools you need to make international shipping easy. FedEx Express ships to more than 220 countries and territories worldwide, including over 200 cities in China. And whatever your shipping needs are, FedEx has a solution that lets you focus on the things that really matter—like growing your business. For more information, go to **fedex.com**. Relax, it's FedEx.®

Your future customers in Beijing are closer than you think.

WIRED
Geekipedia

A SUPPLEMENT TO WIRED

140

PEOPLE, PLACES,
IDEAS *and* TRENDS YOU
NEED TO KNOW *now*

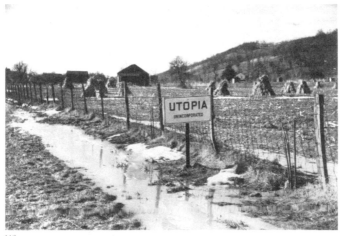

117
Arthur Rothstein
Melting Snow, Utopia, Ohio, 1940

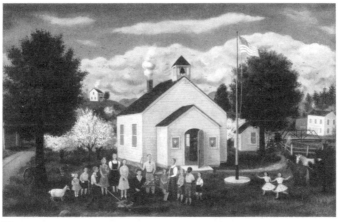

118
Doris Lee
Arbor Day, c. 1941

Le Musée d'Art Moderne de la Ville de Paris / ARC m

A l'occasion de l'exposition

I Still Believe in Miracles

Derrière l'Horizon

Suzanne Pagé
a le plaisir de vous inviter autour d'un **buffet**

**mercredi 18 mai
à 21 h 00**

Couvent des Cordeliers
15, rue de l'Ecole de Médecine 75006 Paris

Ce carton sera exigé à l'entrée

$6.00 OFF

$2 OFF
Regular Adult Admission

$1 OFF
Regular Child Admission

Believe It or Not!®

Ripley's and Believe It or Not!
are registered trademarks of Ripley
Entertainment Inc. 6780 Hollywood Blvd.
Offer Expires 12/31/07

www.filmcasino.at
Kartenreservierung: 587 90 62
1050 Wien | Margaretenstr. 78

02/06

CASINO

MONATSPROGRAMM FEBRUAR 2006

„Ein hypnotischer, außergewöhnlicher Film."

Last Days

Die große Reise – Le grand voyage

Unter den Brettern hellgrünes Gras

7. Internationales Accordeon Festival

Foltinek-Preis

Sunday Afternoon

cine*mama* – Kino mit Kinderbetreuung

Last Days

TimeOut
Athens

+ ΝΥΧΤΑ
ΠΗΓΑΜΕ ΣΤΟ ROMEO+
ΜΟΥΣΙΚΗ
ΣΥΝΕΝΤΕΥΞΗ ΜΕ ΤΟΥΣ FAITHLESS
GAY & LESBIAN
ΝΕΑ BARS ΣΤΗΝ ΠΟΛΗ
CLUBBING
SOUL ΚΑΙ BALTHAZAR «ΒΓΑΙΝΟΥΝ» ΕΞΩ

Brad Pitt
Μιλήσαμε με τον Αχιλλέα λίγο πριν από τη μεγάλη αναμέτρηση της Τροίας

Οι ταινίες του καλοκαιριού

ΑΦΙΕΡΩΜΑ:
Τα συν και πλην των θερινών προβολών

Troy

Japan's Izu Peninsula was the favorite vacation spot for two Japanese literary giants, Yasunari Kawabata (who gassed himself to death) and Yukio Mishima (who committed suicide by seppuku), when they were alive. It has always been a popular recommendation in travel publications. The opposite was found in *Air France* magazine, February 2008, p.140.

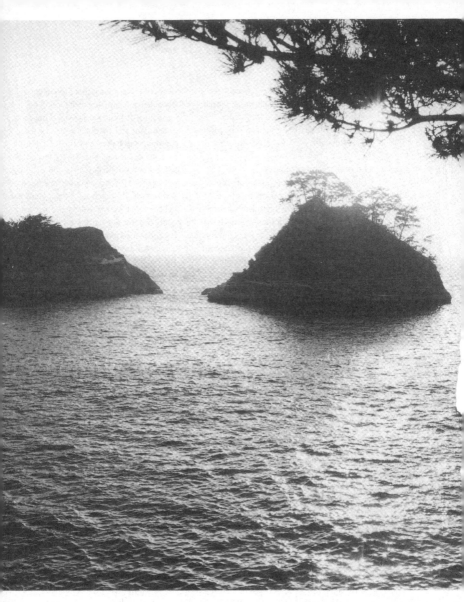

«Chaque goutte de temps qui s'écoule me semble aussi précieuse
qu'une gorgée de bon vin», écrit Mishima à Kawabata à propos d'Izu

n route | Kawabata and Mishima in | Izu

Asia Adult Expo 2008

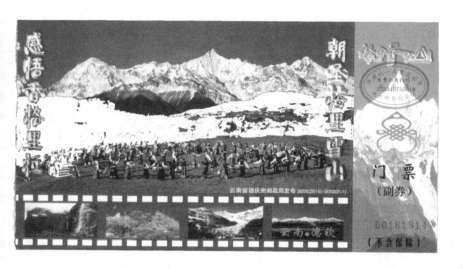

A pilgrimage to the Meli Snow Mountains
To discover Shangri-La

FEBRUARY 23, 200

Revolution Day:
The Trouble with
Talking to Iran

Ben Affleck on
Why There's
Hope in Congo

Why *Grand Theft
Auto* Is Cruising
In the Fast Lane

TIME

Mind & Body
Special Issue

How
Faith
Can
Heal

BY JEFFREY KLUGER

08 >

www.time.ce

60

B: Geometry

BIOCHEM
PATHWAY

GERHARD MICHAL, EDITOR

THIRD EDITION · PART 1

792-969311②-250.

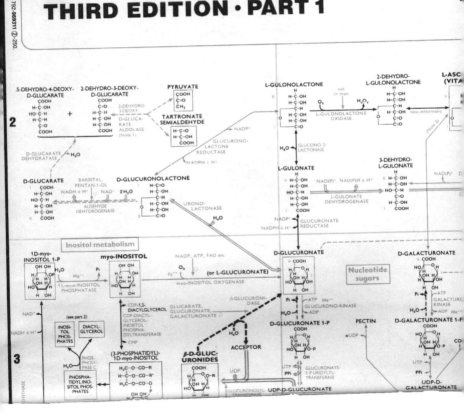

中年、老年人缺乏维生素及矿物质的现象

脱发过早、过多
缺维生素C、B6、钙、锌、叶酸

视力差
缺维生素A、B2、硒

牙齿松动、脱落
缺维生素D、钙

腰酸背痛、腿抽筋
缺维生素D、B1、B6、钙

食欲不振、胃口差
缺维生素A、B1、锌、铁

过早出现老人斑
缺维生素A、C、E、硒

记忆力过早衰退、反应迟钝
缺维生素B1、B2、B6、锌

睡眠质量差
缺维生素B1、B6、钙

头晕、眼花
缺维生素B2、锌、铁、硒

易疲劳、精力差
缺维生素B1、B2、B6、锌

血管失去弹性
缺维生素A、C、E、B2、B6、钙

易感冒、抵抗力差
缺维生素A、锌、硒、铁

骨质流失、易骨折
缺维生素C、D、钙

ping You Beautiful and Healthy》《维生素矿物质营养百科》《新维他命大全》《维他命的效用与疗法》《现代营养全书》

64

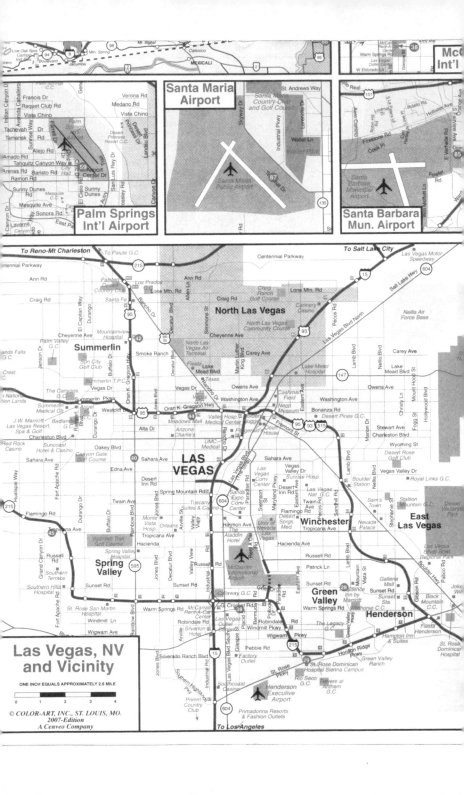

Mariahilferstraße 116
1070 Wien
01/52 66 22 8
ATU: 51103700

Beleg-Nr.: 6102975

Aktionspreis
40210000114505 Netto M
RUNDAUSSCHNITT T-SH16P3C78 11,50 EUR
Alter Preis 22,90
Aktionspreis
30210000165405 Netto M
HERREN T-SHIRT 18,3C76 19,00 EUR
Alter Preis 18,90
Aktionspreis
40210000110006 Netto L
RUNDAUSSCHNITT T-SH16P3C78 11,50 EUR
Alter Preis 22,90
Aktionspreis
40210000110405 Netto M
RUNDAUSSCHNITT N-SH16P3C78 11,00 EUR
Alter Preis 22,90

TOTAL 4 44,50 EUR
Bankomat 44,50 EUR

MWSt 20,00% = 7,42 von 44,50 EUR

Es bediente Sie Benetton Team

Umtausch nur mit Kassenbon binnen 8 Tagen
Kein Umtausch bei reduzierten Waren
Gutschrift ist 6 Monate gültig

Öffnungszeiten
Mo - Fr 9.30 - 19.00
Samstag 9.30 - 18.00

05.08.06 17:50 6118213 2 6 9 1

Baroque

Rococo

Classicism

MAK

Applied Arts | Contemporary Art

Gallery Plan

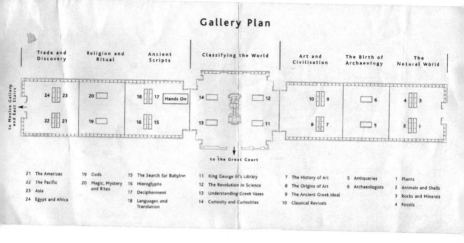

Trade and Discovery | **Religion and Ritual** | **Ancient Scripts** | **Classifying the World** | **Art and Civilisation** | **The Birth of Archaeology** | **The Natural World**

to Mexico Gallery and East Stairs

24 23 20 18 17 Hands On 14 12 10 9 6 4 3

22 21 19 16 15 13 11 8 7 5 2 1

to the Great Court

21 The Americas	19 Gods	15 The Search for Babylon	11 King George III's Library	7 The History of Art	5 Antiquaries	1 Plants
22 The Pacific	20 Magic, Mystery and Rites	16 Hieroglyphs	12 The Revolution in Science	8 The Origins of Art	6 Archaeologists	2 Animals and Shells
23 Asia		17 Decipherment	13 Understanding Greek Vases	9 The Ancient Greek Ideal		3 Rocks and Minerals
24 Egypt and Africa		18 Languages and Translation	14 Curiosity and Curiosities	10 Classical Revivals		4 Fossils

首层平面图

REV. 修订	DATE 日期	DESCRIPTION 内容		阳江市一美设计工程有限公司	NOTES 备注		PROJECT 工程名称	DRAWING TITLE 图纸名称	
								DESIGNED BY 设计	DATE 日期
								DWG BY 绘图	SCALE 比例

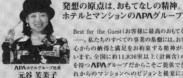

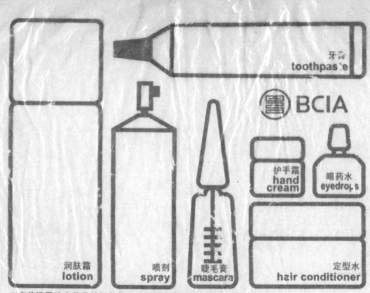

牙膏
toothpaste

墨 BCIA

护手霜
hand
cream

眼药水
eyedrops

润肤霜
lotion

喷剂
spray

睫毛膏
mascara

定型水
hair conditioner

※有关携带液态物品的相关规定请参照中国民航总局的公告。
For regulations relating to liquid objects carried by passengers, please refer to the bulletin released by the General Administration of Civil Aviation of China.

12月18日 · 農曆十一月廿一
Thursday 星期四

今日推介
獵人獵物

乾旱又高溫，加上遊客不斷湧現，
大野生黑熊攻擊人類，
客多嘥生晒好鬼鹽，
分流將佢搬去少人去嘅
迪士尼吧。

33 | 10:00pm

翠台

玫瑰園（重播）	45234
看地球	85379708
早晨	54766050
現場	6830963
交易站	6712437
愛門人	3639296
威 ▶◀	40505
愛要．交易現場	1979944
g You我愛你2（重播）PG	5096494
現場／新聞／瞬間看地球	7267692
紅藍綠仔	6032302
新聞仔	1884505
（重播）	42321
現場．娛樂直播	95302
愛要	6230303
新人王（重播）／交易現場	6656031
CU／摺紙戰士	334418
暴龍DS	71673
交易站（重播）	7881960
新聞	2756811
故娜辭（重播）	597215
／天氣報告／議事論爭	73895
西望	128
自己人	741
入黃金屋	31895

珠台

九台：直播	68578
行情	7658944
現場	7655654
行情	6904128
現場	1876673
街頭玩玩樂II（直播）	8957
獅」法師	7708
小花園III（重播）	9437
丁遊大世界	8296
綜財聯盟／普通話財經閱訊	25741
足球丟未晚	593383
業	7944
／天氣報告／瞬間看地球	925
愛生命力：企鵝先生	296

清　節　目

（無線翠台）J2

／交易現場	15:50 金曲挑戰站
看地球	16:00 管隊王
情	16:30 超級星光大道
子復仇記	18:05 皇家雙辣娜III
域城	18:30 情人一季III ▶◀
自己人	19:00 Music Station
▶◀	20:00 勁歌推介
寶氣PG	21:00 大衛衝衝衝
IM硬戰	22:00 娛 ▶◀
一分鐘	22:30 18禁不禁
OD	23:30 Nana ▶◀

本港台 CTV

5:30am 愛情脆道	
6:29 亞洲早晨	
9:15 理財博客之即市錦囊	
10:20 有腦紀班	
10:50 世間路	
12:17pm 宣傳快線／新聞／天氣報告	
遠途快訊／你有得講	
1:05 颶途王朝開戰軍 ▶◀	
2:05 師奶你好嘢	
2:35 理財博客之投資多面睇	
3:30 比天高比地厚 ▶◀	
4:10 有腦紀班	
4:40 福娃（重播）	
5:10 做之進	
5:40 左右紅藍綠	
5:44 你有得講／天氣報告	
6:00 新聞／經濟快訊／體育快訊	
7:00 鶴間忘	
8:00 亞洲美食100強	
8:05 生活著數台	
8:30 芸姬 ▶◀	
9:00 六合彩	
9:30 王與玫之愛恨燃情 ▶◀	
10:30 時事追擊	
10:52 馬上全接觸	
10:58 三二天 ▶◀	
11:15 夜間新聞／體育快訊／經濟快訊	
12:50am 三三不透	
來在講珠澳	
2:15 連睇天下 ▶◀	
2:20 湖海爭霸綠	
3:15 傳紅雷傳奇	
4:10 逆水寒 ▶◀ PG	

珊曼莎的悠閒週末

54 | 9:00

12 娛樂台	43 HMC	41 電影1台	8 財經資訊台
12:00 大小愛吃 PG	7:15 捉鬼愛情嚇片王	8:35 刀手	13:45 富輪攻略
13:00 高師傅美食俠客行	8:50 熱血球場 PG	12:00 初生之情	14:00 Money Cafe
14:00 轉角遇到愛 PG	11:00 王建達與美建達	12:10 一刀傾城 PG	14:30 外匯先機（直播）
15:00「硬」漢速成班	12:50 BB也瘋狂讀來	14:15 自殺	15:00 財經即時賬（直播）
16:00「硬」漢速成班	14:00 生死時空	16:20 嘩鬼住正陽顧 PG	15:30 商品有價（直播）
17:00 高師傅美食俠客行	16:45 流言偵訊	18:25 公僕II	16:00 交易所直播室
18:00 快刀洪吉童	18:35 奇異恩典 PG	20:30 嘩咕嘩咕新年財	17:00 行情報告（直播）
19:00「硬」漢速成班	20:50 福星活影訊	22:30 不解之謎	18:00 交易所直播室
20:00 大小愛吃 PG	21:20 對抗性侵犯	00:20 票房緣	19:00 財經即時賬（直播）
21:00 高師傅美食俠客行	23:40 燒巴鬼變情懷片 II	2:05 香氣成熟時III 2	20:00 八點�Money財經（直播）
22:00 幸福的眼淚 PG	1:15 積欲風暴	為不鑑情 PG	20:30 Money Cafe
23:00 快刀洪吉童	3:10 美建達與美建達	4:05 藍煙火	

53 Discovery	42 T&L	57 h&h	137 鳳凰衛視中文台
11:00 前進黑野部隊	15:30 奈潔拉的宴客廚	14:00 家有16個小孩	13:30 娛樂大風暴
12:00 流言終結者	16:00 奈潔拉的耶誕廚房	15:00 尋覓夢幻別墅	14:30 鳳凰劇場
13:00 推理探案	17:00 打造完美派對	16:00 豪情家庭物語II	16:00 鳳凰三視野
14:00 打撈地獄	18:00 縱國遊澳	17:00 家事大師3季	17:30 有夠火大讀
16:00 遠征部隊2008	18:30 轉豔拉了美洲	17:30 小達人大世界	18:30 娛樂大風暴
17:00 生活科技大解密	19:00 身單天涯：肯亞	19:00 家有16個小孩	19:00 鳳凰劇場
17:30 製造的原理	20:00 美食天堂	19:30 340公斤重的男人	20:00 鳳凰大視野
18:00 流言終結者	21:00 璀璨拉的悠閒週末	20:00 超完整的春天	21:00 時事直播車
19:00 奈潔不為人知	21:30 全球首選過往家	21:30 小達人大世界	22:00 鳳凰全球連線
20:00 流言終結者	22:00 漫游印尼美食	22:00 領袖家庭物語II	23:00 時事開講
23:00 新時代諸器	23:00 漫游泰國	23:00 340公斤重的男人	23:30 非凡人物論成功

115 HBO	139 衛視電影台	540 星空衛視	670 ESPN
7:00 聖誕頌	7:55 手機凶靈	12:30 街頭拳擊星	15:00 世界體育中心快報
9:00 滑浪勇兵	9:25 翻車玩家	13:00 酷樂LA	16:01 2008/09聯賽快訊
11:00 覺擇尋轉轉	11:00 栗道風靈之收數王	14:00 十三億分貝	17:00 世界體育中心快報
13:00 流言遊戲	12:45 虫不別	14:30 IQ180	17:01 2008/09聯賽快訊
15:00 新城連幸	14:20 銀髮開基爆	16:00 紅蛇世家	19:00 世界體育中心
17:00 大腳八	16:00 嘛不元	17:00 花仔多情	20:00 2008國際摔角
19:00 滑浪勇兵	17:30 甜心粉絲王	19:00 IQ180	美式桌球挑戰賽
21:00 流言遊戲	19:05 呆付用	20:00 鋼鐵風光	凜決賽第二場
23:30 新城連幸	21:00 特務迷城	21:00 紅蛇世家	21:00 世界體育中心快報
1:15 突然死亡	1:15 七塊七億七色狼	22:00 人小鬼大	21:01 足球：進球大匯串
3:00 業報復	00:35 宋家皇朝	22:30 桑榮2008	21:30 世界體育中心
5:00 至激情人	3:00 完美情人	23:00 酷樂LA	22:30 2008/09聯賽快訊

國際台 CTV

11:40am 中國新聞報道	
12:00pm 中央九台直播：新聞一小時	
1:00 今日話題	
1:30 外國人有才藝	
1:40 教育電視	
4:00 捷機讀（重播）	
4:10 可愛小寶寶（重播）	
4:40 飛天小女警（重播）	
5:10 科學of EASY（重播）	
5:35 亞視普通話新聞	
6:05 經濟快訊／天氣報告	
6:05 中國新聞輯錄	
7:25 財經風暴／新聞／天氣報告	
7:25 新生壇	
8:30 大韓航空特約：花花世界時尚	
8:30 六十分鐘時裝誌	
9:05 靈感康（第二輯）	
11:00 夜間新聞／夜間經濟快訊	
11:30 大衛芬機達 PG	
12:10am 中國新聞報道	
12:35 台灣新聞快訊	
1:00 日語大放送（重播）	
1:30 大衛芬機達 PG	
2:00 中國各地／文化報道	
3:05 歐洲藝壇點滴	
3:05 財經遊訊	

8 新聞台	9 經典台	13 TVBS Asia	15 TVB 8
10:05 薬鱧瑪奇朵	13:00 翻軍兒	12:00 全民大咀巴	15:30 世界那麼大
11:00 灰之城 My City ▶◀	13:50 孖寶太子	13:30 整點新聞	16:30 紅豆麵包 ▶◀
12:15 情紅網魂	14:40 九彩霸王花	14:00 健康兩點靈	17:00 終極功夫
14:30 愛情給紀約	15:30 我們的一狄波拉	14:30 女人我最大	17:30 陶伝國台之星
15:00 情女網魂	黃金1季	16:00 驛驛過境	18:00 超級娛樂金接線
18:00 灰之城 My City ▶◀	16:40 香港83	17:00 全民大咀巴	18:30 娛樂最前線
18:05 日月凌空	18:00 翻軍兒	18:00 國民大食	20:00 東京印象
20:05 薬鱧瑪奇朵	20:40 孖寶太子	19:00 新星星知我心	20:30 理想鑰匙
21:15 灰之城 My City ▶◀	21:30 九彩霸王花	20:00 女人大三通	21:00 美食大三通
22:00 情女網魂	22:50 我們的一狄波拉	21:00 整點新聞	22:00 搖怪娛樂頭條
22:30 日月凌空	黃金1季	22:00 馬上九點	22:30 紅豆麵包 ▶◀
3:15 情女網魂	00:30 香港83	23:00 新聞夜總會	23:00 娛樂最前線

無線節目熱線：2335 9122　　亞視節目熱線：2992 9298　　廣管局熱線：2827 8488　　所有節目以電視台之最終

where the (misanthropic) heart is

small gem of a movie, which had more psychological nuance than this emotionally cauterized slice of minimalist malaise.

While Jim's robotically perky mother, Sally (Mary Kay Place), makes a fuss over him, his father, Don (Seymour Cassel), greets him with a wary scowl.

His deadbeat older brother, Tim (Kevin Corrigan), a divorced father of two young girls who lives at home at 34, is so consumed by disappointment that he barely acknowledges Jim's return.

When the brothers finally compare notes, Jim sweetly observes that he may be a mess but that Tim is a disaster. Tim

responds by deliberately slamming his car into a tree and nearly dies.

Jim's father pressures him to work on the assembly line in the family's ladder factory, and before long, he gives in. There he meets Stacy, a k a Evil (Mark Boone Junior), a scruffy, motorcycle-driving drug dealer and the only character in the movie who hasn't fully succumbed to lethargy.

Jim also hooks up with Anika (Liv Tyler), slightly more expressive than usual), a good-hearted nurse and the divorced mother of a smart young boy. Although their first sexual encounter is consummated in less than five seconds,

Anika doesn't seem to mind much and returns for more.

"Lonesome Jim" would be a stronger movie if Affleck ("Ocean's Twelve," "American Pie") had the wherewithal to bare more of the passive-aggressive rage inside a character who contemplates the world with a hangdog, poker-faced stare and drones his dialogue in a neutral monotone. That attitude is convincingly struck, but a more resourceful actor would have used this blank slate to scrawl a thousand telling details about the feelings percolating below the surface.

The New York Times

CROSSWORD | Word Display

ACROSS

1 Berates
8 Customary manner of doing things
13 Orbital extremes
20 City near Fort Roberdeau
21 Smooths
22 Live it up
23 Tornado abhorrence?
25 Nice 'n Easy maker
26 "___ Isn't So" (Hall & Oates hit)
27 Merry-go-round music
28 Change, chemically
29 Where a prince might work at a hospital?
37 Sounds of understanding
40 These, in Madrid
41 Thicket
42 Mekong River land
43 Never
45 Swabs
47 Foreign, to an American, briefly

48 Lesson from Jack Nicklaus?
51 Cargo on the ill-fated Edmund Fitzgerald
53 Close
54 Nike competitor
55 Fakes it
56 Plunder
57 Road warnings
59 Met highlights
60 Homily about gymnastics?
66 Dye-yielding shrubs
67 Oozes
68 Ballet move
70 Forsaker of the faith
74 "___ here"
75 "Peter Pan" dog
76 Users of barbells, e.g.
77 Losers on "The Apprentice"?
82 Coin words
83 Brings in
84 Wore
85 Onslaught of cold weather
86 Kind of princess
88 K. T. of country music

90 Cockney residence
91 Place for unhappy diners?
96 Schools for engrs.
97 Greek theaters
98 Represent
102 Recent reputed spy organization scandal
105 Red Cross sales strategy?
109 Like a size 8 blouse vis-à-vis a size 10
110 "It's déjà vu all over again" speaker
111 Capitol feature
112 Anarchists, sometimes
113 Fresh
114 Extreme joy

DOWN

1 Dosage units
2 Inter ___
3 Tiny, informally
4 This makes sense
5 Boston area, with "the"
6 Response: Abbr.
7 Make lace
8 Goes up against
9 Grammy winner Lou
10 Disciple's query
11 Cariou of Broadway
12 Dropped stuff
13 Entry
14 Camelot sight
15 Spinachlike plant
16 Solo
17 Where Lux. is

18 Inner: Prefix
19 French seasoning
24 Spicy stew
28 Tears
30 Fungal spore sacs
31 Numbered rds.
32 Mark Harmon action drama
33 Ninny
34 Babbled
35 Noggin
36 Tough turns
37 Uneasiness
38 Uproars
39 "The beloved physician"
44 More frequently, old-style
45 One of five

46 Makes a mess of
47 "Untrue!"
49 King of music
50 Pizza places
51 Maya Angelou's "And Still ___"
52 Opens up a hole in
55 Self-congratulated
57 Deep-sea fishing aid
58 Some O.K.'s, for short
59 "What ___!" (famed Bette Davis line)
61 Defeated, in a way
62 Boards
63 Cousin of radial

64 Close by
65 Two-seater
69 ___ basque (dance step)
70 Elite
71 Feather, zoologically
72 Gift ___
73 Traffic control
77 Actress Garr
78 They can be caught at the beach
79 Vacation destination
80 Political slant
81 Spies' info
83 Relieves (of)
86 Nourish
87 Dessert, in Dover
88 Sometime in the future

89 Native South African village
92 Related on a mother's side
93 Maker of Zima and Killian's Irish Red
94 Locker room emanations
95 Recon, perhaps
99 Kind of steak
100 Added conditions
101 "Don't go!"
102 Municipal facility: Abbr.
103 The "Rocky" film with Mr. T
104 In the past
105 Kids' ammo
106 Grazing area
107 Anger
108 Assn.

Puzzle by Mike Torch
Edited by Will Shortz

The New York Times

Solution to puzzle of April 8-9

明珠区

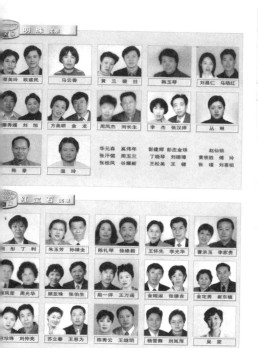

蔡美玲 欧盛民　马云香　黄兰 栾菲　韩玉琴　刘昌仁 马晓红

蔡秀媛 刘旭　方美顺 金龙　周凤杰 刘长生　李杰 张汉祥　丛琳

陈蓁　温玲

华元森　属伟年　彭建辉　彭庄金珠　赵仙铭
张汗儒　周玉兰　丁晓琴　刘德璋　黄宗胜　傅玲
张桂凤　谷耀新　王松美　王健　张璘　刘惠祖

红宝石区

周彤 丁利　朱玉芳 孙祥金　陈礼琴 徐雄毅　王怀先 李光华　曹洪玉 李家贵

周凤荣 周光华　顾亚珠 张伯生　赵一评 王万通　金瑞淑 张德吉　金定男 崔东植

周珍珠 刘仲亮　苏立春 王恩为　陈秀云 王继明　杨雪舞 刘凤萍　吴荚

红宝石区

杨慧勤 杨跃军　周冰霞 张骞亚　吴剑明

王正云　陈凤龙
顾宗耀　徐雪英
林思颜

直系区

曹宏义 周家婷　林海峰 黄安莉　陈飞 王永成　朱敏 陈恩统

薛素芬 赵建华　郑辉 曾庆添　夏宏伟 房耀英　张美英 董喜昌

马桂梅 王吉顺　袁星 蔡利利　付薇衡 林克　袁雪芬 范冰

曾淑勤 邹建军　朱彤 叶梦娟　沈勤 钱胜　周英 何才高

张敏　林鸿晴　李金华　刘玉波

smarke - die Cola, die richtig' knallt, praesentiert die coolsten Party-Pix!

81

AFRIQUE OCCIDENTALE
AIR FRANCE
AFRIQUE EQUATORIALE

crédit photo V. Guerra 1948 - www.airfrancemusee.org

- MENU AIR FRANCE -
TEMPO
- MENU AIR FRANCE -

MENU

85

フロアガイド

施設マップ

ノースタワー

メトロハット／ハリウッドプラザ

ウエストウォーク

ヒルサイド

六本木けやき坂通り

索引

施設別フロアマップ

www. roooonoi hills .com

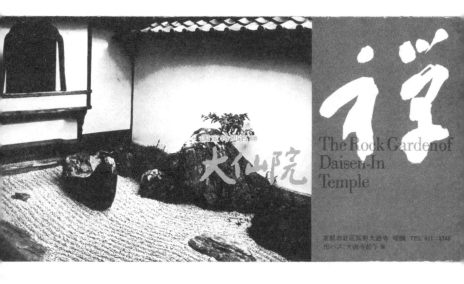

The Rock Garden of
Daisen-In
Temple

当时 然后 还有

then. then, then?

208A-H02P002-01

165/88A

面 Shell

65% 涤纶 Polyester

35% 棉 Cotton

价格 Price

¥ 890.00

当时商贸（北京）有限责任公司

北京朝阳区酒仙桥路2号七九八厂

内706北三街

☎ 86-10-84599495

- - - - - - - - - - - - - - - - - -

208A-H02P002-01

A': Mirror Flower Garden

Since I met you by the river of tears
It is as if a spring breeze has drifted deep in my heart
I want to tell you softly
Please don't forget me

Since we bade farewell by the river of tears
I have been hiding so much pain in my heart
I want to tell you softly
Please don't forget me

How cruel, the autumn winds
That blow down the maple leaves
We still have our youth
Why retreat and fade into despair
Ha, life is but a dream

Since we bade farewell by the river of tears
I have been hiding so much pain in my heart
I want to tell you softly
Please don't forget me

> —"River of Tears"
> Yao Yan, lyrics; Wang Fu Ling,
> composition; Liu Wen Zheng 刘文正, vocalist

It was at a desserts stall that he last met her. Neither of them can remember too well what was said then. The one thing which stands out in his memory now is this: her lips pulling back sharply upon contact with that pink-colored ice cream, and then very rapidly swelling with an incredibly vivid hue, as if they were particularly

made for melting, for separation...

Both of them kept silent, fully aware that a mere sentence could alter the future. However, the easiest thing to do was to act as if nothing had happened, and for each to return to the orbit of his or her life.

At the beginning of the year, he received a creative commission from a theme park, and became part of the supposedly "great unprecedented project."

When he took on the job, large parcels of land in the suburbs had already been purchased by the company. In a bid to avoid clashes with the villagers in the area, wire fences and brick walls were constructed around the land.

Bulldozers were presently razing the fertile green farmland. This was an extremely spectacular sight, with the newly tilled earth filling the air with the "scent of the soil." Under the radiance of dusk, the endless stretches of soil seemed particularly imbued with the solemnity of a land before humanity's birth. For someone like him who was accustomed to encountering the world via the Internet, TV, and magazines, the reality and immediacy of the scenery truly moved his spirits.

Sites should be appropriately selected, gardens should be properly designed.[1]

There was news that in three years' time, the newly constructed

1. This line is taken from an old, yellowed book entitled *Yuan Ye* 园冶 (or *The Analysis of Classical Gardens*). Detailed information about the life of the author, Ji Cheng 计成, (as indicated by the book) cannot be found in any historical books in China. What can be determined is that he lived from 1582-1632, and that he was from Wujiang. He led an itinerant's life, making a living out of his outstanding skills in landscaping and designing gardens. During that period, there was plenty of political and social strife, and people did their best to seclude themselves to keep safe. Ji Cheng constructed numerous gardens, but as he remained powerless and poor, he spent his entire life as a reclusive landscape artist. Before his untimely demise, he wrote *Yuan Ye*—the gardens on paper being his only source of consolation after exhausting travels. If we consider that Jiangnan, a famous city from the Southern Song to Ming dynasties, has now become one of the world's wealthy, arrogant, and extravagant—while the threat of invasion by foreigners lies before us—then it is easier to understand Yuan Ye's influence on the protagonist of this novel: *Yuan Ye*—something that can be considered definite in indefinite times.

metro line #4 would pass through the site of the theme park. That meant that the value of the land could only increase steadily and there would be a guaranteed flow of consumers to the park.

The project team rented a whole storey in the most expensive office tower of the new city's central business district (CBD), situated on the "left bank"—a clear indication of the project's development potential and strength.

Preliminary work: to plan the theme park's architecture with members of the project team. He was in charge of writing the plans and storyboard.

The window of his office overlooked the rapidly growing city sprawl where not a single breathing space remained.

The top-level company executives told him in all earnestness, "He Shan, this is the chance of a lifetime. We're counting on all of you youngsters on the project team to work hard. Remember: to create a world, there's always a price to be paid—but at the end, it's worth it."

What was the adolescence of a country?
Perhaps this was the right opportunity to start his own life anew.

Before joining the company, He Shan had to complete a physical examination. He was taken aback when he saw how his electrocardiogram records resembled little mountain ranges on paper. Despite having endured various setbacks through the thirty years of his life, his physical capabilities had not suffered any damage. The elementary particles within him continued to be mutually responsive and supportive, as if they had an unspoken, unclear mission to accomplish.

Mission? Perhaps it had been concealed ever since the first moment of his existence; it had grown up with him and constituted part of his life force.

According to the Big Bang Theory, the first second is of utmost

importance. So what does this first second indicate?

The sperm thrusts into the ovum at a starling speed, and in an instant, forcefully and swiftly alters the dimension of time. The moment of pregnancy is in fact the birth of another sort of time: in a flash, from a somewhat viscous state, the universe solidifies into a tougher structure. In the first second a fiery material quickly cools and solidifies; it is the period when the world forms a structure. In this one second, within man's physical cosmos, a sperm and an egg fuse to create a structure that can grow and has elasticity. Gradually, it leaves the mother's body and embarks on its own journey towards its destination.

At the point when He Shan left his mother's body, the doctor had to use a pair of forceps to break off the suction from the womb. It was precisely this evil pair of forceps which led to his father's and mother's anxiousness whilst looking after him for the next few months. He was unlike other hyperactive children: he neither wailed nor cried, but spent all day with his eyes blankly affixed to the ceiling. This was enough to make Shan's fretful mother believe that, at the explosive moment of conception within the body, there had been some sort of accident.[2]

"Ah, I was worried to death!" He Shan's mother would often use hand gestures to describe the cruel grip of the forceps on the baby's cranium.

"Aren't I perfectly fine now?" He Shan would respond impatiently.

In the 1970s, He Shan, together with his father, mother, and brother He He, formed a stable little galaxy of their own. Like all other galaxies, each in their individual orbits, they continued

2. Objectively speaking, there is no right or wrong to this sort of "explosion," nor is there any sense of accident or necessity. It is simply a sort of impulse and release. As for the structure of the final outcome—for instance, the baby He Shan—it serves merely to give a sense of rationality to this impulse. This is especially so during the revolutionary era, when impulse must be coupled with reproduction, to generate a rationality endorsed by the revolution. People have often said that the purpose of this act is to nurture future generations of revolutionaries.

revolving around the country's political power center in an unhurried fashion.

To this day, He Shan remembers the first time he was praised by his teacher—all of twenty years ago when he was in the second grade. It seemed to be the only incident in his memory to be proud of.

At the time, his teacher asked the class to make a sentence using the word "determined." None of the students knew what it meant to make a sentence, and only He Shan plucked up his courage and raised his hand.

"We are determined to complete our tasks."

His voice sounded tremulous because of his excitement and pride.

That was the first "sentence" he "made." It was like a curse, because ever since then, he—or more generally, his generation had been diligently working to complete various tasks.

The teacher who praised him was Mdm Yu, an elderly lady who enjoyed smoking; she died of lung cancer ten years later.

Mdm Yu caressed his head after he had made the sentence. He could smell the sharp scent of cigarettes—a smell which he could never forget.

The scent of cigarettes became his madeleine.[3]

3. If we consider Proust to be the first man to articulate the idea of remembrances of things past, then this would be the perfect time for the remembrances of things present—we can contribute to the ever-growing list of consumed items through the years (product names, price, serial number), as well as to records of chance encounters in shopping malls, travel groups around the world (height, weight, body type). Compared to these overly material-based data, He Shan's involuntary memory of the cigarettes would seem to be more poetic and lasting. The cloud of cigarette smoke surrounding the woman has always allowed him to sense the continuity and reality of life.

Let me give you a "recipe" here, so that those of you who are interested can learn to make your own Proustian madeleine (from *Dining with Proust* by Anne Borrel, Alain Senderens, and Jean-Bernard Naudin, original French version entitled *La cuisine retrouvée*, published by Éditions du Chêne, 1991 edition):

Years later, when He Shan first heard about Amazon CEO Jeff Bezos carrying a digital camera with him each day—because he encounters too many people and has to take photos so that he can remember them—his immediate reaction was to recall that first sentence he had made: **We are determined to complete our tasks**.

For some reason or other, he had obtained his own digital camera.

He tried to be like Bezos and grasped every opportunity he had to store his life as a memory.

Yet, while the memories to be saved continued to grow, the hard drive began to make overworked, whirling noises. All that he had around him were photos and raw data, whilst "reality" retreated further into the horizon. The wall was no longer there; instead, through that glass window which overlooked the landscape, he could see the pedestrian bridge on the ground floor. Everything resembled a scene from a computer game.

The digital camera had effortlessly captured reality and saved it on the memory card. Day after day, it transformed life in reality to bytes.

He Shan once tried to scan a number of his small personal belongings: money, identity card, toilet paper, instant noodles, cigarette box, flu tablets, a can of Coke, credit card, CD, remote

Ingredients: 90g butter + 1 cube butter, 90g flour, 75g fine sugar, 10g raw brown sugar, 10g honey, 2 eggs, a pinch of salt.

Melt butter over low heat. Mix eggs, fine sugar and pinch of salt in a large bowl. Add the flour after 5 minutes, and stir it in until the crumbs are light enough to be sifted. Fold the melted butter and honey in with a wooden spoon until well mixed. Refrigerate for an hour.

Preheat the oven to 220 degrees. Remove the dough and let it rest at room temperature for half an hour. Melt the cube of butter and use it to oil the madeleine moulds. Fill the moulds with the dough.

Place in the oven. For smaller moulds, the baking time will be about 5 minutes; for larger ones, it will take 10 minutes. Cool the madeleines before serving.

Note: Madeleines can be served with many desserts, fruit salads, ice-cream, etc.

control, condom, diskette, notebook, plug, photo, an apple... and his own hand. All the scanned images had an incredibly deep, dark background, as if the items had plunged into a black hole.

If you give me enough memory, I can store all of space and time.

The days passed. Then one day, he developed a loathing for the whirling, clattering sound that his computer emitted when saving data (you have all experienced that yourselves). The strenuous sound made him feel ill and exhausted. Later he discovered that this was a masculine reaction towards information overload.

To He Shan, the upsurge of speed began in Beijing's Jiahe Center in 1998. At the time, he felt as if he were on a pilgrimage as he entered the large building with its conglomeration of Internet companies and began perusing the shiny signboards of the businesses there.

The building was not a standalone, but rather opened up to other glorious channels: its marble floors bore the marks of venture capitalists; and you could even hear the crystalline sound of gold dropping on the tiles.

His old classmate Deng Jianguo was working in a well-known company dealing with memory storage. They arranged to meet at the Starbucks café in the lobby. The setting sun cast its rays on bits of leftover pastry. The coffee fragrance seemed deeper than before. As they sipped on their coffees and typed rapidly away at their laptops, he felt a sense of calm despite being in the eye of a storm. At that very moment, at various Starbucks outlets around the world, there must be have been legions of people like them doing their best to savor that tranquility.

They continued to sip their coffees silently, before Jianguo suddenly said, "The online world doesn't need the humanities."

He Shan did not feel particularly surprised. He knew that Jianguo had always liked writing; even during his student days, he was full of interesting ideas.

"I've become an expert in spamming. I've been posting randomly on the net. One day, I'm going to collate all these

meaningless messages and create a website out of them. It'll definitely be a hit. Oh yeah, I'll call it shi.com. As in, lost in meaning and in memory, but still poetic.[4] Who knows? Maybe a venture capitalist will be interested in it."

"That's a great idea. You should trademark it quickly."

"Gotta seize on opportunities to make a load of money, so that I can retire on my thirtieth birthday, write the stuff I want to write. And of course, travel around the world."

He Shan managed to join the company with Jianguo's recommendation. Half a year later, the company was forced to leave that temple of online business. Deng Jianguo was twenty-eight when his "early retirement" was enforced.

Of course, he was not the only one who suffered that fate: during the dot-com bust and subsequent meltdown, He Shan had also been forced to find a new job.

Who picked up the tab for the "Deep Blue Generation"?

We are searching for a profit model from within the conflict between real and virtual worlds.

In front of the villa by the lakeside woods, "memory" on the barbeque grill will always retain its warm fragrance; in that spacious and stylish gym, you can see the URL of "memory" emblazoned on the backs of all the fitness outfits; at the family buffet dinner, every carton of the "memory" beverages will have a number printed on it, you can win a prize once you go online. At the moment, it looks as if "memory" itself is some sort of online company: aside from its website (www.ji-e.com), it has yet to develop any material products. Yet, the goal of "memory" is not limited to the Internet. Rather, it began from the Internet, and uses the immense online network to create online products, before rapidly proliferating them via the network. Through on- and offline

4. The Mandarin pronunciation for "lost" (shi 失) can refer to the loss of memory, loss of meaning, or a poetic quality. Unfortunately the wordplay is lost in translation.

interactivity, it offers consumers an all-round lifestyle product and valuable information service.

Although profits are hardly on the horizon at the moment, the unique profit model offered by memory is something that has attracted the industry's attention. Yang Yue, the CEO of "memory," hopes to develop it into an Internet brand. "Since there's no precedence for creating a branded lifestyle product on the Internet, naturally our methods will have to be distinct. 'Memory' allows you to create your own personal value system, and through that force, design a well-known brand. When you agree with the values of 'memory,' then you have accepted the 'memory' brand as well. Therefore, rather than saying that 'memory' entails building a brand, it would be more appropriate to say that it creates a culture. In the branding strategy of 'memory,' culture is intangible and yet the sharpest tool we have." That is the impassioned description of "memory" given by CEO Yang Yue. Even in the current slowdown of the Internet industry, this sounds like an attractive and grand objective.

"Usually, the development of a world-class brand would require a period of more than ten years as well as investments of a few billion US dollars. Does 'memory' really have that sort of potential?" Yang Yue's response to these sorts of queries was remarkably relaxed. "Well, that is the difference of the Internet age. Through the Internet, the construction of a brand would be much easier." Is it really as simple as Yang Yue thinks? If we interpret the idea of a brand as synonymous with a familiar phrase, then Yang Yue is certainly right. This was proven during the economic boom of the last two years. Huge sums of foreign venture capital were swiftly transformed into billboards on public roads, advertisements on the exteriors of buses, full-page ads in the newspapers and magazines. Very quickly, people became familiar with the names of new Internet companies. However, what makes a brand is not simply how well-known its name is; it still has to have its own culture and purpose. Does the brand name of "memory" achieve that?[5]

5. Excerpted from *New Economic Pioneer*, no. 12 (1998).

When he analyzed the reasons for the dot-com bust, He Shan would always think of that crazy party in Beijing.

It was in a contemporary courtyard within a private residence in Ju'er Hutong. Under the flickering candlelight, He Shan noticed a heavily made-up, middle aged woman with a smile walking towards him. She had a cigarette between her fingers. He began to feel a twinge of regret.

"You are one lucky son of a bitch. This is your 'Capital Motivation' for the website," Deng Jianguo said in a low voice as he leaned close to his ear, before flashing a grin and moving to another corner of the house. A girl over there who had just drawn a lot and had to perform a striptease dance was hollering like a spoiled child, "It's not fair, it's not fair!"

He Shan was still holding the ballot in his hand. On it was written "It doesn't matter whether it'll be forever." If he guessed correctly, the lot in her hand would have said, "As long as we have the present."

"Drawing lots is totally fair." The woman's voice was rich and thick, as if she had been vocal training. From just hearing her voice, one would inevitably have somewhat indecent thoughts.

"And I thought it'd be very democratic here," he replied, pretending to be sophisticated.

"Darling, it is a very focused democratic system here. A woman like me and a man like you are a perfect match. It's like a venture capitalist finding an elite management team. Aren't you going to ask me to dance?" She looked straight at him.

Very soon, they were in a deep embrace. Her thighs slid snugly between his thighs, without any sense of shyness.

When a few candles were extinguished, her hands grasped his waist tightly as they moved downwards, and then downwards.

There are no apprehensions at this sort of party.

Within barely two years, the dot-com bubble had burst. Whenever he thought of the crazy liaison with this "Capital Motivation" in the bathroom, he could almost taste the trace of menthol cigarettes in her mouth again. He suddenly realized how apt the metaphor she came up with then was: her extraordinary

insight on the relationship between men and women was evidence of her familiarity and understanding of the ever-changing relationship between a venture capitalist and management team.

It was a shame that their insane passion, like the Internet bubble, ended swiftly; he did not even have the chance to tell her that he was a virgin.

In fact, just like Deng Jianguo, He Shan had literary aspirations, which had begun in his secondary school encounters with lyrical poetry and prose in textbooks: *Writings on Camellia, Who Is the Most Lovable Person, Short Notes on the Cane Forest, Singing with Abandon:*

I could see
starlight
and lamps
in happy unison in the night sky

I could see
the alpenglow
and the windlass
dressing the dawns up.[6]

Through the innumerable recitations in class, He Shan learned about the most precious elements of "description, comparison, and metaphor" in Chinese literature. Literature is no longer a personal love or hobby, but rather, a song of exultation for an era. As such, literature permeates and constructs the dreams and ideals of a generation. When he first heard the news about the workers' strike

6. Taken from He Jingzhi贺敬之's long verse, *Singing with Abandon*. In his book *Against Predestination: "Socialist Realism" (1945–1976),* Li Yang commented, "This is the image of the 'Motherland' as depicted in *Singing with Abandon*... The poem is replete with sincere praise for the contemporary nation that has been constructed after enduring countless difficulties and dangers. This is our common essence. We are no longer lonely in this new nation; we are part of an invincible collective body. From here, we can discover each and every person's value and meaning in life. From here, we can begin living, creating... " (Times Literary Publishing House, 1993), 231.

at the Three Gorges Dam, his immediate impulse was to think of Liu Baiyu's *Three Days on the Yangtze*:

I stood alone on the dock of the boat. The river winds were fierce and the surroundings were a total pitch black. Countless searchlights from the roof of the boat were cast onto the river's surface. Above the Yangtze, the skies were overcast with fog. The flickering lights, coupled with the sounds of wind and water, not only accentuated the awe-inspiring momentum of the thunderous river and gorges, but also made you realize how close you were to nature. It was as if the universe spread out right in front of you. The water and sky, the wind and fog—everything melded into one entity, as if it was not the boat but rather you who were wrestling with the river currents. "The dawn of a new epoch is right before us, and we must work hard for it." At this moment, my soul was filled with a grand and wonderful feeling. It was as if everything that I had experienced in this era had, in a flash, gathered together and manifested itself on the surging Yangtze River.

The sort of intimate association one feels with a particular era can easily excite him, and serve as a provocation for him to look for even newer thrills. Although He Shan has yet to grasp a similarly fervent emotion for this day and age, he instinctively knew that his passion would not be found in the fallen lost.com. On the contrary, he could attempt to demonstrate his personal observations and thinking through his theme park project plans.

He worked night and day on his Draft Plan for the Construction of Garden of Mirrored Flowers, which he handed over to his superiors in the company. In it, he detailed:

Unlike currently existing theme parks which are devoid of creativity, our proposed theme park aims to be a place where visitors can enjoy intense personal experiences. It is a theme park thriving with the humanities, where visitors can simultaneously experience multiple levels of enjoyment through channels such as the fine arts, entertainment, and education, which will all become

part of the experience economy.[7] The theme park will then be a facilitator between visitor and society in terms of inculcating the visitor's sense of responsibility and thinking skills.

In simple terms, the Garden of Mirrored Flowers' basic strategy is to differentiate itself from the rest.

The design and construction blueprint of this theme park will be drawn from *Flowers in the Mirror* (*Jing Hua Yuan* or 镜花缘),[8] a novel written by Li Ruzhen (李汝珍) in the Qing Dynasty. The plan will be revised in a creative manner, transforming it into a highly experiential project for the cultural industries.

We will break through the novel's original lengthiness, convoluted narratives and sequences, and by separating the wheat from the chaff to extract its essence, we will refine this data into thirty-eight theme areas, fifteen lead characters, and five navigation routes, interwoven into a rich and vibrant realm of life.

Precise computer-generated design will effectively direct construction work in our endeavour to build an unprecedented world-class attraction—an outstanding spectacle that can only be

7. In *The Experience Economy*, Joseph B. Pine and James H. Gilmore systematically clarify the value of the experience economy: "The newly identified offering of experiences occurs whenever a company intentionally uses services as the stage and goods as props to engage an individual."

He Shan heard the two authors giving a speech at an international symposium on developments in China's economy, society, and culture in the twenty-first century. At the time, he had just emerged from the meltdown of the Internet companies and was searching for a new direction. The viewpoints offered in their book were an enormous moral boost and insightful for him. The authors of *The Experience Economy* believe that man's economic life has undergone four major developmental stages since the caveman era: agricultural economy, industrial economy, service economy and experience economy. By considering experiences as unique economic goods, we now have the key to open up future growth and development in the economy.

8. In *Introduction to Flowers in the Mirror* by Hu Shih 胡适 (1891-1962, Chinese philosopher and essayist) he writes, "*Flowers in the Mirror* is a novel that talks about women's issues." "This nation of daughters is Li Ru Zhen's utopian system, where women's rights are fully developed." Hu Shi's evaluation from the past still holds great significance for us in our understanding of this work, particularly with respect to the consumer society in which women are seen as objects of desire. Re-looking at *Flowers in the Mirror* would provide us with new insight today.

attained in this epoch.

When tourists from all over the world arrive here and find themselves amidst rare flora and fauna, surrounded by beauties in a "place beyond boundaries," they will not help but sigh:

"Ah, life is but a dream."

If we regard the Internet as a virtual trap that gives the illusion of interpersonal contact and the hallucination of freedom, then this theme park will transform the virtual trap into something with substance that you can touch. It will allow people to believe that the dream world is real.[9]

The sensations that visitors to the theme park will experience are precisely those that classical Chinese literature has always wanted to convey: life is a bewildering maze.

As such, we can better comprehend one of the key principles for the construction of the theme park: **bewilder—the soul—intensely**.

The main travel routes in Garden of Mirrored Flowers will be based on those of Tang Ao, Lin Zhi Yang, and Duo Jiu Gong, characters in *Flowers in the Mirror*. They will take on the roles of travel guides who will guide "guests" (according to the theory of the experience economy, all tourists would be equivalent to "guests") as they enter this fantasy world. The novel itself has already provided the general principles for the design of these routes. As per the travel sequences determined by the novel's characters, our "guests" will visit:

Country of Noblemen
Country of Adults
Country of Workers
Nie Er Country
Wu Chang Country

9. The best example of such a world thus far is the late superstar Michael Jackson's private theme park, Neverland: the legend of eternal youth.

Quan Feng Country
Mao Min Country
Pi Qian Country
Shen Mu Country
Hei Chi Country
Country of Little People...

The project design team will be subdivided into small groups to design five routes, based on the attraction potential of these countries:

Water
Wood
Metal
Fire
Earth

To provide guests more freedom of choice, the fee for each route will be the same.

In order to build a unique experience, we propose to construct an "artificial sea." Visitors will need to travel by raft across the sea in order to reach the other areas of the theme park (also known as "islands"). Within the islands, links in the forms of bridges, porches, and pavilions will be constructed, such that the islands will be reachable from one another easily.

"I traveled through perilous situations to come back from there..."

Different lives will be manifested at each route.

He Shan kept seeing two scenes manifest before his eyes:

Scene 1:

It was summer vacation. He Shan and his fellow companions were wearing their red scarves, their hands holding on to insect

nets as they sprinted up the hill, enveloped by the heady fragrance of the pine forests. When they reached the top, they looked down and noticed how the placid reservoir's surface resembled a mirror.

Potential energy has transformed into kinetic energy... the guide said as he pointed to the seemingly bottomless reservoir.

During the summer camp at the reservoir, he became infatuated with a shy girl from Wenzhou with black hair and bangs. They worked on insect specimens together under the dazzling summer sun (oddly enough, these insects did not have a smell to them), sang together, and competed together. They exchanged addresses when it was time to part. Her handwriting had a faint freshness to it. Thereafter, their contact gradually faded for no particular reason.

Scene 2:

His old home was right next to a famous park. When he was young, He Shan played on his own in the little caves within the rocks, under the shade of trees or amongst the flowers—he could feel himself being enveloped by the moisture in those spaces which had nurtured the flora and fauna for many years. He had always felt that there was something hiding within and which had something to say to him. However, he could only muddle through the woods in confusion, and never did manage to find an answer.

One day, his brother He He told him about a dream he'd had:

In the dream, he saw many people walking naked in the park. He was among them as well. As they moved through the feathery willow seeds drifting around them, his lower body accidentally brushed against a flower stamen. The seeds floated with the wind and the leaves of the trees began to morph into the soft skin of the opposite sex...

It was a shame that at the time, he and his brother were unable to determine the details of what was being revealed to them. However, through his own dogged persistence to learn more about physiognomy, He Shan helped his brother suss out the basic cause of the dream: this was his brother's first wet dream ("We are determined to complete our tasks.").

In the process of deciphering the dream, he vaguely understood

that the garden was the playground of grown men.

It is only when you fully immerse yourself within that you can finally experience this: the multitude of shapes and stances in which you find peach blossoms symbolizes the myriad appearances that females have, and serves as a glimpse into the variety of fun you can have; the disparate movements of willow branches in the wind hint at the different depths of lust and desire you could have; the shifting silhouettes of bamboo implies the ever-changing nature of life... fish swimming in the water are symbols of temporal pleasure.

Since he went abroad for his university studies, He Shan's contact with his brother became more sporadic, until they finally stopped communicating altogether—this is exactly what one would never have imagined in the past, but does occur today: in the technological age in which communication is so convenient, we still lose touch with our loved ones.

Garden of Mirrored Flowers differed from its classical counterparts in that it was developed rapidly with the "plug-type city" as its foundation.

This so-called "plug-type city" refers to the form and structure of the most economically progressive and highly efficient cities of today. Briefly, all cities have their fundamental existence rooted in standard hardware provisions as well as connecting interfaces. Inter-city connectivity can be arbitrarily linked up. The relationship between the central city and its surrounding smaller townships is akin to that between the main plug and the switchboard. From here, we can effectively solve the problems of inequality in terms of economic development among Chinese cities as well as the abuse of authority by regional governmental institutions.

As a result of the different means of connection, various situations may arise in the city, with the common ones pertaining to:

1. Connection Docking

2. Connection in Series

3. Connection Accessibility

4. Connection Containment

From these, different types of groups can be formed, such as:

If we take Z City, where He Shan is situated, as an example, it would be considered a classic Structure 4: surrounding a few phallic skyscrapers (the energy emitted from these landmark constructions often boosts the morale of city dwellers and workers) are various other sorts of buildings that disperse outwards like eddies, thus creating a sort of undulating concrete jungle. The trees lining the sides of the streets have been pruned into various geometrical shapes. Even within the public gardens, you can find plants in geometrical forms, and both young and old are able to stroll and relax among them.

A migrant like He Shan is well aware of short circuits that occur in this "plug-type city": the grey overcast skies, with viaducts stretching aimlessly into the distance, on which countless little cars cluster tightly as if they were lice feeding on a blood vessel; the sounds of piling resounding through the city at all times; cheaply rented, cloistered accommodations that never see any sunlight. Fluorescent lights were left permanently on, casting their harsh glow on the dust in rooms, remnants on tables, the dried apple core on the floor, soaked slippers, darkened under-eye bags, a faded birthday card slumped mutely against a wall.

Garden of Mirrored Flowers promises to injtect a sense of fresh green respite into this "plug-type city." The subtle slowdown in life's pace that it provides is akin to a channel of wind blowing through the little gaps between cities piled against one another; it is like a spell of rain, or a soft and gentle sigh:

Ah, life is but a dream.

According to the original design draft, each of the themed areas within Garden of Mirrored Flowers should be "hyperlinked" to another (for instance, via high-speed monorails), such that visitors can maintain a rapid momentum as they enjoy the magical charms of this hyper-reality. However, in the process of construction, I began increasingly to feel that the process should be an intermittent walk from one area to the next, like how a moving essay is extracted from a grand narrative—this is therefore the second principle in designing gardens: **the form may disperse but not the spirit**.

"The power of imagination is more important than that of knowledge." This was a line of encouragement that a teaching intern had written in He Shan's junior high graduation souvenir book.

The original statement was made by Einstein. At the time, the teaching intern cunningly used it as an analogy for the double bind that the Chinese education system had placed on the creativity of its students and teachers. Yet today, everything that surrounds He Shan's life is evidence of how accurate this saying was, because all imaginings of the future in China seem to lag behind a reality which alters at a blinding speed.

After the dot-com meltdown, He Shan relocated to Z City—a model " plug-type city"—as a base for him to develop his career. One of his main reasons for doing so was that Z City provided the social mechanisms particularly conducive for personal development. These sorts of mechanisms possessed some sort of spontaneous explosive power that far exceeded what people imagined.

Once, He Shan stayed within the electric-generator room in the reservoir, surrounded by the rumbling water. There, he gazed for a long time at the silhouette of the girl from Wenzhou, as she stood in front of the shiny dynamo, listening attentively to the engineer explaining the principles and workings of the reservoir's generator. He was overwhelmed by the imposing machinery that seemed to embody Socialist theories to benefit thousands of families, and was

also moved by the Wenzhou girl's conscientiousness. He made a vow to himself that he would become an outstanding engineer.

If someone had told him then that he would become an outstanding business project planner when he grew up, he would have thought that person was out of his mind and was trying to ruin his dreams for the future.[10] At that time, the word "business"—just like the word "sex" (known in Chinese textbooks as "physical hygiene")—was shrouded in total secrecy.

Now, when he realized that he could easily complete a marketing proposal for breast augmentation products (after the baptisms of fire that were his marketing training, and the Internet business collapses, he could finally conclude with confidence: successful proposals are all similar; those which fail all have their own defeats), he could imagine the teaching intern from his school days no longer having to sigh, but rather becoming someone like Li Yang, who could strive for a revolution in the Chinese education system, thereby becoming one of the first pioneers in altering the fate of the Chinese population.

Because of job requirements, He Shan would often have to accompany General Manager Ma from the company to view the construction site. He never grew tired of looking at the bulldozers shoveling the rolling waves of soil. The mounds of soil glistening under the sun and filling the air with that earthy fragrance somehow possessed a sense of inexplicable, imperfect beauty.

Some of the work to relocate villagers living on the site had begun by that time.

"At the end of the day, we're the ones who're giving them

10. As a reference to this scene and its corresponding sentiments, readers can look at a corresponding passage in Russian author Victor Pelevin's *Babylon*: the protagonist, Babylen Tatarsky, had became by default a member of Generation "P" since birth, although it was a long time before he had any inkling of this fact. In those distant years, children were expected to direct their aspirations towards earning the shiny helmets of firemen or the white coats of doctors, and certainly would not have thought that what awaited them in the future was a job as a copywriter. In the Chinese translation of this book, Pelevin's foreword brought our attention to one of the greatest traditions of Russian literature: "In Russia, writers do not write novels; rather, they write scripts."

employment opportunities, aren't we?" General Manager Ma's voice sounded very faraway.

A month later, the dirty mud road through which they were passing would become a straight and flat public road, lined on both sides with coconut trees that evoked the sunny Southern climate.

He suddenly thought of his father, who survived arduous times when he was once living in the Great Northern Wilderness in China. During those times, they had to use their bare hands to turn the wastelands into arable farmland; today, those solemn lands were again undergoing new historical experiences.

It was dawn in July, and the sun had just emerged. The land, blossoms, and deep green sorghum leaves were awash with a golden glow. The dewdrops glistened like countless, dazzling pearly eyes on the bean-shoot leaves and vine tendrils. Firewood, tinged the lightest green, was placed on the side of the road by the stable, whilst smoke wisps drifted from the tall yellow roofs. Herds of cows and horses began to move out from the stables towards the prairies to feed.

This was the opening paragraph from one of He Shan's father's favorite novels, *The Tempest*. (He would always sigh as he remembered the past and would say, "The northeastern mountain villages were just so beautiful.") Very quickly, the mountain village's tranquility would come to an end with the arrival of the "Land Reform Task Force." A huge four-wheel carriage dashed madly towards the serene village, thus heralding the "tempest" that would rouse the villagers from their bliss and sleep.

Although He Shan knew next to nothing about the details of the work done by the "Land Reform Task Force," as he was seated in the long-distance jeep moving through the terrain, his father's subtle influence was evident in how he recognized a historical connection between himself and the "Land Reform Task Force": they had accepted the responsibilities for similar missions, and they penetrated deep into the mountain villages to construct a sort of new order for the times.

He Shan stared at the back of the head of General Ma, who was seated in front. He tried hard to think about how this plot of land would look, how it would connect with the other "plug-type cities," and how it would travel into a new future.

Whilst waiting for the proposal to progress to the next definite stage of development, He Shan, aside from playing online games, became a fan of a book entitled *Notes on Meng Yuan*.[11] He discovered that, like Yuan Ye, this book was rather helpful in coaxing him into a peaceful sleep after hectic work periods.

This book was written in the final years of the Southern Song Dynasty and recorded the turmoils of that era of immense upheaval,[12] as well as how a private garden provided a spiritual respite for a young man at that time. From the beginning of *Notes on Meng Yuan*, the author informed his readers: although he is nearing the twilight of his life, he could feel more acutely that no matter how things changed, the dream garden in his heart would always retain its most basic elements: trees, rock gardens, water and gravel paths. The author emphasized that should this garden be destroyed in the future, and future generations felt incapable of restoring it to its former glory, then they should let the garden disappear. As long as you possess a calmness of heart and mind, then you will find traces of this garden in any other garden around you: trees, rock gardens, water and gravel paths—they will tell

11. "Meng Yuan" (梦园) translates as "Dream Garden" in English.

12. In his publication *La Vie quotidienne en Chine à la veille de l'invasion mongole*, French historian Jacques Gernet meticulously described the final years of the Southern Song dynasty (1227–1279), particularly the peaceful periods before the invasion of the Mongols, and specifically with regards to social and cultural life then. In his foreword, he wrote, "With the development of research, the fundamental image of China that we had constructed is gradually vanishing. Once the mists shrouding its silhouettes clear, we will discover that China's history is not one which is built on continuity and immutability. Rather, it is one that exists within a series of shocks, chaos and destruction." What is notable is that around the year 1275, Lin An (临安) was considered the world's largest and richest metropolitan area. Some historians and engineers in China have already begun identifying connections and similarities between the manner of development in the city then and that of "plug-type cities."

you similar stories. Therefore, do not be worried when a particular garden vanishes from reality, just as you should not fret about physical degeneration and death.

The author further explained that we already know our destination from the moment we commence this journey. It is not important when the tale begins or ends. Conversely, different entrances, journeys and experiences become pivotal aspects of this journey. The author himself also fades away along these routes, dissipating into countless fragments of leaves, traces of light and cracks in the wall. In a manner of speaking akin to Zhuang Zi: When does my dream end and the garden begin, the garden that is in my dream and is part of me? This is the reason for the title *Notes on Meng Yuan*.

Notes on Meng Yuan: Entrance

One day, as night descended, my uncle went out for a stroll. What differed from the usual was that after he left for the park, he never returned.

From that day on, my father sealed the exit to the park. The sole entrance to the park was also locked. We were warned to never wander outdoors as we wished.

However, I knew that someone would enter from the other side of the entrance. I even saw some strangers lingering around the entrance, and they certainly did not obtain my father's permission to do so.

I seem to have had the ability to see such disappearing silhouettes since my childhood.

Notes on Meng Yuan: Screen Door

There was a drawing of a rabbit dashing off in the center of the screen door. Its pair of ears are erect, its bobtail raises high as it gallops away; its left paw is turned slightly in the drawing, as if it were thinking about something in the midst of its escape. In the dim background, one could see vague images of pine trees, bamboo

and plum trees (termed the "three friends") and little flowers that resembled stars.

Many years later, I discovered that the image of the rabbit was taken from religious paintings from the West. The rabbit is the embodiment of a saint, and the act of running represented the omen of change. This particular sort of change would only make sense to the person experiencing it, but would be deemed absurd by anyone else.

When a famous geomancer had completed his visit to the site after lingering there for three days, the top executives at the company finally had some feedback on the project team's draft proposal. According to Ma Cong's view, the project team made some rather large amendments to the routes in the theme park once again, and He Shan suggested the following plans:

Taking the South China Sea as the starting point, guests will travel by water through Routes A and B.

Route A, also known as the Road of Sense, will pass through the Dong Shan entrance, Country of Noblemen, Tian Mu Island, Country of Workers, Wu Gu Country, Pi Qian Country, Shen Mu Country, Hei Chi Country, Shu Tu Country, Country of Two Faces, Shou Ma Boundary, Bo Lu Country, Zhi Jia Country, Pu Du Bay, Little Peng Lai.

Route B, also known as the Road of Sensibility, will pass through the Dong Shan entrance, Country of Adults, Nie Er Country, Wu Chang Country, Country of Ghosts, Mao Min Country, Bai Min Country, Yan Huo Country, Yi Min Country, Wu Cheng Country, Qi She Country, Country of Women, Country of the Yellow Emperor, Pu Du Bay, Little Peng Lai.

In reality, guests can choose to commence their journey on Route A and then take Route B back to their starting point, or vice versa. Whatever the case, they will have undergone the same journey by the end. However, the choice of commencing either with "Sense" or "Sensibility" would inevitably influence and increase the enjoyment of the guests' experiences.

The designs of the travel routes will include twists and turns

with various diversions, and will be coordinated with accurate calculations of the journey's duration and schedule, done electronically. This is to ensure that there be no instance of two different boats meeting each other along the routes, and as such the scenario will always be that of a lonely raft adrift in the wide open sea.

The advertising tag-line will be: "Are you ruled by Sense or Sensibility?"

Most of the project team's different opinions centered around whether the name "Road of Sensibility" was appealing enough. Most of them felt that guests who visit theme parks are simply addicted to the loud, colorful entertainment that theme parks offer.

The new intern Xiao Ping managed to impress He Shan greatly during this debate, when she brought up three reasons robustly supporting He Shan's suggestion:

1. In China, there is now an unprecedented recognition among people for the importance of culture. "Knowledge means production capacity" has become a consensus in society.

2. Aside from its entertainment value, the theme park would certainly possess the function of increasing knowledge and education. This would effectively increase the theme park's cultural aspect. Did we not note that the first line in Disneyland's brochure is "Knowledge and happiness are equally important"? Walt Disney himself had also stated that Disneyland would be a place where "people discover happiness and knowledge." This was precisely in accordance with the Confucian notion of "the joy of learning," and hence worthy of consideration by Chinese people today.

3. The sense and sensibility components of the theme park complement each other and cannot do without the other. The idea of "sense" would already imply sensory organs, just as sensibility is augmented by sensorial factors. It is when the two are concurrently incorporated that the "guests" (He Shan was pleasantly surprised to discover that she had begun using the term "guests" as well) can enjoy a rich and full personal experience.

Although Xiao Ping was merely an intern, her position as a post-doctoral researcher in classical Chinese literature accorded her with a certain "first priority" in speech. It was clear from her eloquence as she spoke that she must have participated in high school debating competitions, arguing on both the prosecuting and defense teams; her manner of speaking had an undeniable influential and infectious edge.

It was a memo from the marketing department entitled "Forecasts of Returns from Routes A and B in the Project" that finally put the argument to an end.

He Shan was not too sure how the marketing department had done their calculations. Whatever the case, the final conclusion was this: regardless of the names for Route A or B, their designs would definitely accelerate profit returns.

In fact, for He Shan, the rationale behind the naming of the routes was completely personal: if we regard the upper half of the human body as being ruled by sense, then the lower half would be ruled by sensibility. It is with the combination of the two that a perfect human form is created.[13] He was just embarrassed to say so.

13. It is worth noting that generally, in all languages, a large portion of expressions involving non-living things utilize metaphors referring to the human body and its individual parts as well as human perception and feelings. For instance, we use the term "head" to describe the top or beginning; the terms "brow" and "shoulder" are used to describe a mountain's position. Needles and peas are all said to have "eyes"; cups and pots have "lips"; rakes, saws, and combs have "teeth." Any gap or hole can also be called a "mouth." An "ear" of corn, the "tongue" of a shoe, the "throat" of a river, the "neck" of the land, the "arm" of the sea, the clock's pointer which is called a "hand," the "heart" being the center, the "belly" of a ship, the "foot" representing the end or bottom, the "flesh" of a fruit, the "veins" of rock or ore, wine being "the blood of grapes," the "flank" of a piece of land, the "smiling" skies or sea, the wind that "blows," waves that "swallow," the "groans" of items under heavy weight... we can find various examples of this in all languages ... The above describes how man has pretty much transformed himself into the entire world by anthropomorphic descriptions. Hence, just like a rational doctrine in metaphysics, this sort of imaginative metaphysics—where man becomes everything by understanding everything—demonstrates how man tries to grasp an understanding of that which he does not comprehend by referencing himself and becoming that entity himself. –Extracted from Vico's *The New Science*, sec. 405, trans. Zhu Guang Qian (People's Literature Press, 1986).

This statement by Vico could be a mental footnote for He Shan's idea of "the perfect

When He Shan woke up in the morning and looked down at the gray and foggy city below his feet, he was suddenly consumed by a sense of intense desolation.

He Shan suddenly realized that ever since he had taken his job head on, with the exception of briefly browsing social networking sites or chatting online, he had not experienced any physical sensation. All his hopes and desires were focused on the design of the theme park—it was as if he had temporarily lost interest in his own body.

He took a sniff of his laptop case (a Sony 798 ultra-thin streamlined notebook)—it had a slight scent akin to seminal fluids.

Was it a projection of his remaining youth?

As an outstanding product of the Chinese experience economy, Shenzhen's "Window of the World" was particularly significant. However, as more and more Chinese left the country to travel abroad, "Window of the World" faced an inevitably grim situation: the models differed sharply from the real landscapes and places of interest. If this problem was not handled appropriately, it could lead to an "experience failure." Garden of Mirrored Flowers' superiority lie in the fact that it would be constructed entirely like a dream world, and hence there would be no real version to be a source of comparison.

Mirror, mirror, reflecting, a kind of nothingness.

human form." The situation in reality is exactly what Freud described in *Civilisations and Its Discontents*: "Man has, as it were, become a kind of prosthetic God. When he puts on all his auxiliary organs he is truly magnificent; but those organs have not grown on to him and they still give him much trouble at times." In his book *Five Bodies: Reconfiguring Relationships*, John O'Neill points out, "The waning of the discourse on personification represents a major change in our view of the structure of the universe. Previously, people usually used their bodies to perceive the cosmos as well as use the cosmos as a contrast to the body—a sort of harmony and unity existed between the universe and human body. Now people's thought about systems and structures no longer originate from a flesh and blood spiritual entity." Therefore, this can reflect the importance of balance between the design, sensorial, and sensibility aspects of Garden of Mirrored Flowers.

Flower, transient like a blossom, the colorful world, is also a kind of nothingness.

Garden of Mirrored Flowers uses the reality of pleasure to contrast against a sort of nothingness.

Nothingness + pleasure, like similar artificial models of pleasure, are in fact the most wonderful.

We have become addicted to this sort of pleasure.

The Taoist nun in the novel said:

I have never been able to bear the torment of reincarnating back here in the mountains

Let me return to the shores of the sea of sorrows

While the multitudes of people in the "plug-type city" float on from day to day, Garden of Mirrored Flowers exists like an island where these people can finally land. Like a magnet, it attracts the surrounding iron pellets; or more accurately, it is akin to the center of a galaxy.

Just like the flower fairies,[14] we have all fallen to earth, having lost our inner equilibrium. As such, no one would turn down the opportunity to enjoy the spiritual release and pleasure that this kind of theme park can offer.

Garden of Mirrored Flowers is hence a psychodrama of an even higher class.

Therefore, we should be able to understand the third principle for the construction of the park easily: **the world's experiential center**.

He Shan should have had enough opportunities to explore and experience things in the gigantic and unfamiliar city. On many late nights as he made his way home in a taxi speeding through the empty streets as if it were a computer game scenario, he would suddenly feel an intense desire to understand the city, to walk into

14. This is a reference to the flower fairies in *Flowers in the Mirror*, who were condemned by the gods to fall to earth when they acceded to Emperor Wu Ze Tian's demand that all flowers in the world were to bloom overnight.

each and every street that he did not recognize and into each tiny room within, to enter into other people's lives.

Yet in the daytime, he did not have the same urge to understand it. He agreed with his colleagues: the city is destined to be just a workplace; once they established their careers, they would shift to other "plug-type cities," even more refined and humanized to enjoy their lives. As such, during their stint in Z City, aside from work, they had little reason or need to have interpersonal relationships. As they traveled to and from work each day, all they had to do was glance at the expressions of people on the subway, and they would be able to imagine their lives as they are.

At night, if he had the time and energy, He Shan would sit quietly before the computer and wait for his Internet lover to come online. They would talk like lovers do, and He Shan's fingers would caress his heated keyboard with great speed. When their conversation moved to a climax, he would quickly go off to take a bath. Those little tadpoles of life (which always evoked the image of the animation *The Little Tadpole Searching for His Mother* in his head) would rapidly solidify into countless cotton-like granules the moment they hit the water, gently floating to the surface. Some of them would attach themselves to various parts of his body, some would stick to the edges of the bathtub. A sweet, silky scent would emerge from the water to fill the bathroom until it felt like a closet filled with cosmetics.

That would be the perfect way to end the day.

Notes on Meng Yuan – Waves Overlapping on the Cliff

Explorations of these rocky terrains are often coupled with memories of the stench of lichens in dark caves and oddly enticing shapes from Taihu Lake. Even though I am familiar with the little paths on the limestone formations, each foray into the hills brings forth a different experience, depending on when the trip is made. This is especially so when I enter the hills with different people; the whole mountain would seem to emanate unique atmospheres each time. For instance, I would distinctly detect the scent of orchids on

Second Aunt's body. My grandmother would always stop midway into the journey to rest on a rock stool, and whilst she did so, I would have traversed the entire cliff.

I have never imagined that there would be a more thrilling and constantly evolving scenic spot than this cliff. Sometimes, after climbing up to the peak, my entire body would heat up, and I would gasp for breath due to the exertion. As I gaze at the faraway lake and pavilion, I would experience dizzy spells temporarily. For a moment, I would vaguely sense a mysterious line of sight—one that almost seems borrowed from someone else's viewpoint. Could that be a line of sight which my father had meticulously planned out?

My father often told me that one could travel through all of China's famed mountains and rivers, but they could hardly be as fascinating as the rocks and waters in our own garden. I never really understood what he meant, until I saw a landscape painting for the first time, and felt as if suddenly enlightened.

What I had seen was from my father's collection of Li Cheng's famous works "Paintings of the Distant Mao Forest." The light ink made the scenery resemble dreamscapes enveloped in melancholy; the wispy faraway woods appeared somber and profound. His landscape paintings made me feel somewhat lost and dislocated.

He Shan was thirty-two years old when he finally read Che Guevara's diaries from the South American jungles. His idol's travels as a youth across the length of South America thrilled him once again and made him realize that despite his nausea on seeing the multitudes of T-shirts emblazoned with Guevara's head, Guevara would always be that man who never stopped growing up through his travels and debilitating illnesses; the man who unified philosophical meditations with the smallest desire for a bowl of soup; the asthmatic explorer who also dug his own grave. Guevara was the "I" that each of us used to be—that open-minded "I" that all of us no longer admit to being.

"Man, the measure of all things, speaks here through my mouth and narrates in my own language that which my eyes have seen..." These words rekindled He Shan's yearning for a life that was fast

like the wind, pure and sensual. He had been moving for too long from his company in Z City and back, from his company's office and back, from the shopping mall next to his office and back, from the products for sale displayed at the mall and back. It was only when he finally looked one hundred meters down from the office, separated by a glass wall from the city gloomy after the rain, that it hit him: he had already become a tourist maintaining a safe, non-threatening distance from life. That life with "true meaning" was at the horizon, beyond his line of sight—his eyes seemed just about to crave something different from the norm, but this impulse would vanish quickly as daily life took over.

What other impulses did he have?

During secondary school, his language teacher had asked him to recite Karl Marx's *Reflections of a Young Man on the Choice of a Profession*:

If he works only for himself, he may perhaps become a famous man of learning, a great sage, an excellent poet, but he can never be a perfect, truly great man.

If we have chosen the position in life in which we can most of all work for mankind, no burdens can bow us down, because they are sacrifices for the benefit of all; then we shall experience no petty, limited, selfish joy, but our happiness will belong to millions, our deeds will live on quietly but perpetually at work, and over our ashes will be shed the hot tears of noble people.

Perhaps then, he did not realize how those lines would have any relation to his life. When he read the bit "over our ashes," he was surprised to smell a whiff of cigarettes. When Mdm Yu, that teacher who was fond of him because he could construct sentences, finally passed away, the whole class of students went to the crematorium and even wrote a remembrance speech as a class. His line, "Tonight, the stars are speechless, the sky lowers its veil," was inspired by what he felt when he walked down the corridor after a late-night study

session and looked up at the sky. At the cremation, he remembered his nostrils being invaded by a sharp, stinging scent of burning that was unlike anything else he had experienced. For a split second, that scent mingled with the cigarettes he could always smell on his teacher, and for the following week it lingered sadly in the air. He still had not shed a tear at the end of it all.

On his way back to school, he gazed at the small hill beside the crematorium which had been demolished for mining purposes, its insides completely exposed like a disemboweled body. In an instant, he understood what that line from a famous pop song meant: "Some folks say, life is like a play."

Compared to death, nothing else really seemed to be of significance. From then on, he would often use death as the ultimate yardstick against which to measure the degree of severity of situations: compared to death, lousy exam results were of course not worth fretting over, not being able to enter university would of course not be as grave as his parents claimed it would be.

During history lessons, He Shan disagreed with the criticisms that his teacher made of emperor Louis XV's famous comment, "After me, the flood!" Since he had witnessed a human body's degeneration into ash, it was as if he could see through a lot of things.

Even now, He Shan had hardly any fear of death, just as he had very little impulse for life. What was strange was that a sort of zest for life was very evident in his father. Last year, his retired father joined a landscaping company to work as a project consultant to enhance greenery in the city. Whilst enthusiastically working to create a beautiful tapestry of plants throughout the city, his father even more actively read essays by Liu Bai Yu and Yang Shuo. In his later years, as he demonstrated once again his gratitude towards society, He Shan's father melded his social life and his appreciation for lyrical prose together, like he did perfectly as a youth.

Notes on Meng Yuan: Route

The meandering paths seem to lead towards an endless forest.

Yet I have never felt exhausted when I wander through these roads.

What is amusing is that each time I start running, I can sense two distinct atmospheres brushing across my body: sunshine on the left, silhouettes on the right; chill right in front, warmth at the back. As I speed up, these atmospheres slow down. They are constantly altering, harmonizing with my skin's sensitivities, creating a symbiosis with my being. The stars and insect calls of the night, the dew and watermarks of the morning, the branches that reach deep into the walls to transmit news from beyond the garden—my entire world seems to be the here and now.

"And my entire world seems to exist between the apartment and this office," He Shan thought to himself.

Although the decor in the rooms at Z City had different styles, they all had the same basic elements: table, mirror, bathroom and window curtains, not forgetting the broadband connection for the computer—just as gardens would have their basic elements. Naturally, we could perhaps add people into the equation: man or woman. He Shan imagined it as a common and nondescript hotel room, with a man standing by the window, looking down at the city bustling with light, his lover embracing him tightly from behind.

At the cabin seats in the Western food café, He Shan spotted Xiao Ping's youthful and exuberant face, and could smell a sour stench of overripe gingko nuts.

Xiao Ping was working on her PhD thesis on the history of women's rights in Chinese literature. She held the same view as Hu Shi: *Flowers in the Mirror* is the first Chinese novel in history that "spoke openly" about women's rights, the author having articulated his twelve different ideals for women's independence through the characters of hundreds of flower fairies. Therefore, these hundreds of flower spirits scattered amongst the islands must become the protagonists of *Flowers in the Mirror*.

He could see the self-confidence expressed in her demeanor, and felt like telling her that there is no absolute male or female gender (since time immemorial, Chinese people have admired men

with feminine traits most of all), nor is there absolute love (having a number of wives and concubines ensures total harmony), and it is only through mutual movement and mutual exchange that we can maintain harmony and development: Marxism and Maoism, black cat-white cat; he felt like telling her that there is no way to become acquainted with another China, a China with a garden-like consciousness has permeated the souls of all Chinese people, a sticky and slippery China, a China that is feminine and gentle yet remains spurred on to expand its influence and power, a China that is rotting away yet still making love to its beautiful scenery, a China that is inscrutable despite standing right before your eyes—she has already vanished forevermore, and there is no way to find her again. All that remains are some traces and markings, some erotic art, an old tree, a broken bridge, the muffled sound of a guqin. Yet these material forms will decay very quickly in the world, they will be immersed and transformed into nameless particles in space and time. If these particles could express themselves, then they would be the tender green shade of bamboo, the fragrance of porridge, the flawlessness of dewdrops on flower petals at dawn...

Yet, he could only respond coolly, "Your suggestion has a lot of potential. I believe that the flower fairies will undoubtedly be a highlight in terms of tourist attractions, but it's best if they remain hidden within each island, to be discovered by the tourists themselves. Don't forget, the theme park is a stage on which guests can display their own personal styles."

Don't forget, "experience" is what makes each guest participate in the events, each in their individual ways.

They are the real protagonists.

When they parted ways, Xiao Ping stared fiercely at him while from under a streetlamp that was illuminating tree branches waving in the breeze.

"Actually, you don't understand me at all. I am just a woman who is easily hurt."

He thought to himself, unfortunately she is not a flower fairy who was easily hurt.

With regard to some essential details about the plants in Garden of Mirrored Flowers: the oleander is a plant that is a mixture of the bamboo and peach blossom, with petals that are as light as snow, and blossoms which hang downwards softly... From *The Book of Songs*, we know that people from that period lived in single-led tribes, where spring and autumn festivals were times for sex... and, there is the drifting seaweed too.

My favorite is the gingko tree, which has markings on its leaves that form a mirror image of itself: the two become one. Some people detest the sour scent that is emitted by ripe gingko fruits, but I love that fragrance intensely, because it is the female mating call.

There is also the peach blossom, which in Japanese is pronounced "momo," and in colloquial speech means the female sexual organ.

One should realize that all the flower fairies in *Flowers in the Mirror* are female. That point is hardly coincidental, and reflects the implicit sexual innuendos that Chinese gardens and landscapes have, as subtly displayed through the idea of balanced Yin-Yang harmony and beauty:

> *A young man in his twenties viewing flowers*
> *The empty cave within Tai Hu Lake*
> *Water trickling between the rocks' cracks*
> *Passing through the labyrinth*
> *Like a translucent lace curtain (inspecting the borrowed scenery)*

An elegant yet perverse sexual consciousness had altered the world of that period, and that in turn conceived numerous gardens, landscape paintings, classical Song poetry and short stories. Today, our worlds are similarly changed through virtual relationships and love over the Internet.

Notes from Meng Yuan: Strokes

Through the cracked ice on the garden's ground, I can make out strokes of Chinese characters. The beginnings of fissures are evident on the green slates. If you scrutinize them, you should be able to foretell the future.

I am often confounded by the symmetry of leaf patterns when I pick them from beneath the gingko tree. The markings on the leaf's top half would mimic those on the bottom half of the same leaf. Moreover, the leaves of the same tree would be astonishingly similar. Would this be as Lao Tzu said, "The Tao gives rise to the one. The one gives rise to the two. The two gives rise to the three. The three gives rise to all beings"?

When the gingko fruit ripens, it gives off a special acrid scent, one which my mother particularly loathed.

During my classes, I would secretly wish to see the illustrations in Shan Hai Jing:[15] *mermaids, Changyou Mountain, the celestial hound, the Emperor's three daughters, mystical god of Dongting Lake. My understanding of* Shuo Wen Jie Zi[16] *made the old teacher I detested develop the hope that I would become a "Confucius scholar" he could hone. I could decipher the meaning of words with great accuracy, simply by looking at their characters. Chinese characters were—in my eyes—pictures formed by horizontal and vertical lengths and breadths. Each word depicted a story. I loved words but I did not like reading, to the great dismay of my teacher.*

The rainy season delayed the progress of the project.

The air at the muddy work site was tinged with a fresh fragrance after the rain. The cable lines looked blurred from afar, but gave a sense of confidence to the construction. This was exactly the result

15. *Shan Hai Jing* (山海经) is also known as *The Classic of Mountains and Seas.*

16. *Shuo Wen Jie Zi* (说文解字) is also known in English as *Explaining Simple and Analyzing Compound Characters.*

of repeated training that our generation had received during art lessons in school: cable lines represented the great accomplishment that self-reliance in socialism has achieved, and symbolized happiness in people's lives.

If we regard this artistic pattern as a reflection of national consciousness, then it must be that we have been immersed in this country's halo of light ever since we were young. The individual with his limitations must meld into unlimited collective activity in order to find meaning in life (ensuring cleanliness and hygiene, distributing one's own newsletters, mass jogging at dawn...).

The history of a new country coils like a spiral upwards and beyond, and its future will continue to retreat deeper into infinity.

When he woke up in the morning and noticed the long-awaited sunlight stretching across his blue settee, he suddenly thought of those multi-colored building blocks he used to play with in kindergarten, and how they would always smell of fresh paint that had not dried during the rainy season. Once when He Shan was ill and was not given sick leave, he sat alone in the large activity room playing with building blocks. He piled the blocks haphazardly, and they would always collapse with a crash at the end. At that point, he would not have imagined that his actions as a child would be like a scene from a movie in his mind today. The stench of burning (this time, somewhat akin to the smell of celluloid in flames) engulfed him once again.

Have our lives become too dramatic?

Alternatively, have we made our lives too dramatic? Impressions from his childhood have become an unforgettable montage ("building blocks" foreshadow a massive construction project for him), and life today, a rehearsal for a video recording from the future.

A rehearsal implies that errors and amendments can still be made. Once the curtains are lifted, there are only two choices: success or failure.

A series of worker sheds stood by the road in the gloom and

dampness. These roughly constructed asbestos sheds had been weather-beaten so badly that they were in a dilapidated state, and their interiors were pitch dark, with a pungent moldy stench. The workers sat playing cards and chatting. He Shan got a fright when he stretched his head in and saw nothing but the whites of their eyes flash in the darkness.

During this period, He Shan discovered a new pleasure in swimming in the rain.

The swimming pool in the area was not large, but because the rain obscured one's view, the edges of the pool seemed to vanish. When he dove into the water, he was able to see the gorgeous patterns formed by raindrops striking the surface, creating soft lines similar to stretch marks. He felt enveloped by the safety of a womb, secretly watching the bright lights of the external world from within.

That girl would turn up at the swimming pool everyday at the same time as him, and would always swim in the opposite direction towards him. Whenever they met at some point when crossing the pool, he was able to feel the ripples emanating from her center of gravity gently caress his skin. However, she never once turned to look at him, instead focusing completely on swimming.

It was only the two of them in the tiny swimming pool at dawn. He Shan could even hear her gasps for breath.

He Shan's main preoccupation during his leisure time from work was the computer game the Sims. In most cases, he would prepare by purchasing instant noodles, before plunging deep into a fugue to concentrate on the game at hand.

This time, he traveled extremely lightly and flew to the indicated unknown island.

Each time, my luggage would always be minimal and light, and would never exceed the limits imposed by the airlines.

This time, my luggage has diminished even more than before.

I intend to purchase items over there: a short-sleeved Hawaiian shirt, sunscreen, a pair of swimming trunks in navy color, a shaving mirror, a toothbrush, a bath towel, a pair of slippers, reading material for leisure. I can use my accumulated points from before to get these daily necessities for free.

I hope I can arrive at my destination as quickly as possible to complete my mission.

The plane flies through layer upon layer of clouds as it descends, and the slight turbulence makes everyone somewhat nervous.
I try as hard as I can to look through the porthole window in the plane.
Will she appear at the appointed place?
(I can almost smell that floral fragrance from the South.)
I am suddenly reminded of a song by Jacky Cheung (张学友): Love is the power...
Meanwhile, large stretches of ocean become visible through the clouds. The island appears amidst the scenery, just how little dots slowly manifested themselves in the pond at Taihe monastery.

The airport is situated on the beach.
As the plane lands, the waves begin undulating from afar, making it feel as if the airplane is skidding along the ocean's surface.
As I emerge from the cabin, I can feel the humidity sticking onto my skin. The distant landscape is obscured slightly by fog. This is the island I have been dreaming about; this is the real thing.

He Shan hit the key to suspend the game. He opened his window to take in a breath of air.

A narrow but terribly noisy motorbike takes me to the Holiday Inn, which is hidden amidst plantain leaves.
From the window in my room, I can only see a small lane and

some large patch of unknown greenery.

A wooden reclining chair sits on the balcony.

The bathroom and bedroom are separated by a set of brown wooden blinds.

There is a bouquet of little white flowers on the table, which must be smelling very fresh.

I hurriedly move the flowers aside.

Sure enough, there is a note on which is written:

"This evening at 6 p.m., Temple of the Sea God."

I check the map. The description says that this is currently the most well-preserved ancient maritime territory in our country. There are about 5,000 uninhabited islands. The country is encouraging private rental of these areas to develop the islands.

The Temple of the Sea God is situated at the brink of a black precipice, and is a holy land where trespassing is also prohibited. Without special permission, no one is allowed to enter.

The rock formations here are made of pure black sedimentary rock, a mysterious and odd crystal formed by black volcanic lava upon contact with the bitter sea. Huge portions of them stretch out along the coastline to the horizon.

When you pass through this area with black rocks, you might chance upon a poisonous snake or strange beast. However, generally speaking, as long as I am cautious and my senses remain sharp, these things do not threaten me in any way. Rather, the real menace is this: when the doors of the Temple of the Sea God open, you really have no idea what can happen; perhaps if you are not paying attention, you could easily lose your life. To a certain extent, it is true to say that life does not mean much, and it is just a tool to help us fulfill our desires; when life is over, then it is just over, and that is that. However, in this case the point is the following: her life has been entrusted to my hands, and she needs my help in order to return to the homeland that she misses immensely.

Her name is the Fairy of the Hundred Flowers.

That day, she tried everything she could to pray for the Empress,

so that all the flowers would bloom together on this winter's day. However, the gods in heaven were furious with her and condemned her to descend to earth.

This is a rather boring story. So what is it that attracted me? The beauty of flowers? Sympathy for the fairy? Love, or the desire to rescue her?

This island is actually a hub, or rather, a starting point.

Aside from a golf set in the hotel room, I had acquired nothing else.

As I walk along the steep slope of the golf course towards the seaside, the magnificent scenery before my eyes makes my heart skip a beat.

I swing the golf club, and can hear the sound of the ball dropping into a hole.

The caddie drives me speedily to another hilltop. Over there, there are even more difficult intersecting golf courses. If I can score with another ball, I will be able to find that secret alley that leads directly to the seaside.

At this point, the caddie smiles coldly at me.

I decide not to be affected by him. I have to concentrate my energies and strike!

The golf ball travels in a parabola across the pond, but when it finally hits the ground, it rolls back into the water.

The caddie's smile remains fixed on his face, as he moves towards me, closer, and closer...

The sky had darkened.

He Shan opened a packet of instant noodles.

The steaming hot cup of noodles always gave him a sense of being able to survive arduous conditions.

In Korean dramas featuring pop idols, instant noodles have almost become a prelude to subtle beginnings of romance between men and women. The toughness of the noodles evoke the idea of binds in, and between, people. This is especially so on rainy days when it seems as if every single person isolated in his or her

own dreary, tiny flat is scarfing down instant noodles as a relief from loneliness. Countless men and women ate instant noodles simultaneously; the little sachets of seasoning in each packet peppered the city atmosphere. Through this action, they are better able to recognize one another as well as get together, thus orchestrating a symphony of love.

General Manager Ma liked listening to Beethoven's *Pastoral Symphony No. 6* in the car. As the long-distance sports utility vehicle sped through the suburbs, the *Pastoral Symphony* unwittingly bestowed a tinge of pink and emerald green onto the large factory buildings and strangely shaped makeshift huts of the villagers that they passed by. Suddenly, the polluted surroundings were clothed in a kind of purity.

General Manager Ma would shut his eyes as he listened to the symphony, but when he reached the end of the third movement, he would gradually open them again and gazed fixedly out the window, as if he had made all preparations for the imminent "tempest." When the fourth movement began, and the tempo decreased to evoke an atmosphere of unease, General Manager Ma would start to accuse the immature travel industry of wrecking the beauty of China's landscape, and would contrast it with the situation in Europe; as the "tempest" in the music gradually died down, and the pastoral sounds of the piccolo drifted in, he would close his eyes and immerse himself in that feeling of gratitude and joy that comes after a storm.

The more he heard, the more He Shan began to understand that the development of dominant symphonic musical themes was just like the three laws of dialectical materialism: The Law of Opposites, the Law of Negation, and the Law of Transformation, with the three forming a spiral that leads to a higher level, which then calls for the same laws once again, thus progressing into infinity. He would often encounter the same process whilst playing computer games: the game begins, develops, and ends, and then leads to another round of play on a higher level of difficulty. In Beethoven's world, man's will ultimately triumphs over merciless

fate, and emerges victorious over all evil power; man is his own master, and that is a historical necessity and end-point.

The pleasure derived from listening to Beethoven is similar in some ways to that gained from playing computer games. We know from the beginning that our efforts will be futile, but the importance lies in the process of the struggle and the amusement we get out of it. What computer games aim to do is imitate an abstract human life. While they are hardly as sublime as Beethoven's music, when the gamer is absorbed in his quest, it is as if his fate were in the grasp of the keyboard; the victor will be rewarded with an unprecedented self-confidence, which makes up for the disappointment he experiences in reality.

When He Shan heard the *Pastoral Symphony* once more, he tried to listen to it from General Manager Ma's point of view, so that he could comprehend the reason why the fundamental theme of the Pastoral was also that of "the hero and nature": it is a song of exultation for the man who is the master of his fate.

He Shan finally saw that "Capital Motivation" lady again, though this time she was on the cover of *New New Magazine*. Because of the ingenious photo angle, her plump figure seemed to exude an ample allure; she maintained her classic stance: both arms crossed against her chest, her eyes looking confidently into the camera, thus giving the impression of an extremely wise middle-aged woman. The interview stated that she had placed her venture capital investments into lifestyle spas to capitalize on their popularity. "In this era of the experience economy, people no longer have to worry about filling their stomachs, but rather only have to worry about not having good creativity. An excellent thought can solve all problems. Changes in the economic mode are often related to the depth of change in our mentality and thought," she revealed breezily.

He Shan tried his utmost to recall every detail of how their bodies met, but aside from a vague sense of heat, he could no longer remember anything tangible. He stared at her full lips (with that taste of menthol cigarettes) on the photograph again, and knew

that regardless of any future opportunity, he would not achieve any sort of physical intimacy with her again—unless he became a really successful person.

He gave Xiao Ping a call, and unexpectedly found out that she was pregnant. For a moment, he felt the world darken around him.

Notes on Meng Yuan: Cracks in the Brick Wall

I often peer at the scenery outdoors through cracks in the brick wall. The cracks seem to filter out the noise in the landscape, to present a kind of simple beauty to my eyes.

This is a moment for the object of my hopes. I need only shift my line of vision ever so slightly, and the landscape before my eyes would immediately reciprocate by presenting a fresh perspective to me, as if to encourage me to unravel the relationships between each layer so that I can bridge their differences. I hold my breath as I watch in silence. If a small bird enters the scene with its twittering at this moment, it will draw me back through this rich diversity of my reality. I will then return to this side of the brick wall. I am on this side, and the landscape is on the other side. The disparate patterns on the brick wall—resembling water chestnut flowers, braids, bamboo, herringbone—intensify that special feeling I get when I enter the landscape.

Scene 1: Ray of Light
"With light comes everything else." Part of Garden of Mirrored Flowers' river will be constructed based on a sheltered indoor concept, with the use of artificial lights for illumination, in order to better create different ambiences, landscapes and styles during the course of the journey. Of course, ideally the whole of Garden of Mirrored Flowers would be enclosed within this artificial environment, with a central system controlling the occurrences of the four seasons, the blooming of flowers in different areas when required, and so on. This is what we believe would evoke the idea: "A day in the mountains is like a million years on earth."

Suddenly I thought of the time during my childhood when I visited the Beijing Astronomy Museum to watch a movie. I lay on one of the reclining chairs and looked up at the arched screen that resembled an enclosed hut. The lights dimmed and in an instant, the sky was full of twinkling stars, while the amiable voice of a male announcer said, "Dear children, when you look up into the sky, have you ever thought of this?: Right in the heart of our great homeland..." I fell asleep, wishing that I could stay there forever.

Scene 2: Ocean

This can be controlled by an artificial wave-generating machine, with small encounters with danger included in the design to add to the fun factor of the theme park. However, it is essential to note: this theme park is not a water amusement park; the structure of the waterways is meant to draw the visitors' attention towards the mystical islands and the fairies on these islands.

Scene 3: Tides

We will begin embarkation each time the tide is high. The duration between the tides will be thirty minutes, which will be controlled by a man-made tide generator. Each boat will be equipped with a pair of tour guides—they will undergo collective training to familiarize them with all ten characters, including Tang Ao, Lin Zhi Yang, and Duo Jiu Gong; and their role is to draw the visitors into the scenarios of the theme park as quickly as possible. Once we consciously use our services as a stage, and the theme park as props and sets to ensure guests become immersed and involved, then the "experience" will be manifested.

My fascination with the sea chart and tides is purely so that they can serve as stage props to manufacture a sort of theatrical navigation experience. The artificial wave-generating machine purchased for Garden of Mirrored Flowers will not only have four presets (regular semidiurnal tide, diurnal tide, irregular semidiurnal tide, irregular diurnal tide), but will need to have the artificial intelligence capability to run automatically, in order to create

a richer and more colorful navigation experience. The myriad elements—roundabouts, navigation signs, large arcs, small arcs, geometric projections, tangent points Z and M, meridians and the equator, the shifting lines indicating wind directions on a sea map—will serve as hints for the mariners, so that they can select the best navigation plan. These also demonstrate the complexities of the meteorological information, navigational experiences and oceanic terrains that must be researched and understood in detail.

"If I am a nomadic sailor, then you are the unchanging destination..."

Clad in traditional costumes, the sailors begin their journey during the monsoon, carrying with them the well-wishes of their wives and their longings for chance encounters during their travels—such a moving and tense moment for one and all.

Notes on Meng Yuan: center

My father's unflappability stems from his confidence in the world that surrounds him: no matter how the world changes, we will always be the center of the world, and this garden will be the center of the center.

Even if we are bombarded by news about the barbarians' invasion from the south, the entire city will not collapse into frenzy. Rather, the numerous creatures here will remain as they are, the cerulean waves continue their ebb and tide, and everything will appear as harmonious as before. To me, the barbarians on horseback are just figments of my imagination. I have never seen a prairie, and can only imagine it through lines in poetry:

> *The murderous air pushes up in a haze*
> *A jade curtain parts the East and the Yellow River*
> *A prompt dispatch is sent to the city walls of Leh*
> *Night sheds its robes to comfort the fallen generals...*

Unfortunately, this is merely a dream of Lu You.[17]

Because Beijing City's population continues to increase, buildings are forced to develop upwards as skyscrapers, such that there is hardly any space left to view the sky. People are most concerned about how they can live comfortably in the limited space available to them. The "Emperor" has encouraged folks to add extensions and renovate existing buildings, such that these structures would look more palatial, in order to induce deep shame in the hearts of the invading barbarians on horseback. With respect to this, my father had even "received caution" from the powers that be, leaving him with little option but to renovate the front of our homes extensively.

I only need to step into the small alley in the garden, stroll between the green hills and blue waters, and in an instant, I would feel as if the cacophony outside is of no concern to me. I vanish within the middle of the garden, just as the world disappears into the garden.

He Shan looked out of the window. The dark skyline was dyed a lurid red by neon lights, and gave him the illusion of leaping into a pink void. He had never before felt such an intense desire to merge as one with anyone or anything else. It was a shame that it would never be her—that girl who smelt of gingko.

The computer screen flashed with an ambiguous florescence from a pornographic image accompanying a downloading webpage.

He suddenly suspected that people are no longer interested in real physical experiences.

If flowers are the genitalia of the earth, plants represent the crystallization of love, and green leaves are the skin that sticks close to my being, then it would be a disgrace if I took the initiative to embrace, since it is the inability to touch that is truly beautiful

17. Taken from Lu You 陆游 (1125-1210)'s poem "Night of September 16 – Dream of the Garrison's River Dispatch Effectively Overcoming Zhucheng."

and eternal.

Xiao Ping could acutely sense He Shan's recent indifference towards her. She did everything she could to argue with him: in her opinion, the allocation of roles to female workers already demonstrates the problem of gender discrimination. Since *Flowers in the Mirror* is China's first novel that discusses women's rights openly, then "Garden of Mirrored Flowers shouldn't reenact the tragedy of history." Yet, for He Shan, since it is reenactment, it could not possibly constitute a real tragedy anyway.

What Xiao Ping criticized most was how He Shan allocated roles to the candidates according to their backgrounds, for instance:

A previous gymnast: Yan Zi Xiao (Female God of Speed)
A previous performer from a Xinjiang dance troupe: Yin Ruo Hua (King of the Country of Women)
Graduates in Chinese studies: female talents Tang Gui Chen, Hong Hong, Ting Ting, etc.
A girl from the village: a slave girl

Xiao Ping saw this as not merely evidence of gender discrimination, but of class discrimination too.

"But there's nothing inequitable about this. Here, all success will be dependent on the intrinsic energies of each of their own efforts," He Shan tried to explain.

Yet both were aware that this was not the real problem at all.

The key issue was that he could not convince Xiao Ping to go for an abortion.

Points to note regarding the role-playing of the fairies:

1. They will all be played by ordinary people, and these people have to possess the air of deities.

2. To make the fairies more lovable, they should be seen in appropriate everyday settings (in the novel, we often see them gathering together to share laymen's jokes; for instance, in one joke, the fairies term feces "yellow food," which does not sound too crude in terms of its inferences). As such, day-to-day details should not be excluded from the role-play, but should be elevated

and performed as artistically as possible.

3. As such, they will appear detached from daily life, and become a sort of unattainable landscape.

In contrast, Garden of Mirrored Flowers provides a robust background in order to create three important elements for the relationship between the park and the people:

1. The guests and workers together become part of the whole set (props).

2. The guests and workers become actors in a large-scale epic drama (lead roles and supporting roles).

3. Garden of Mirrored Flowers becomes a space of psychological transformation for the guests and workers.

The general idea is that the theme park encourages everyone related to it to become a "brand new you," thus creating a realm in which the park and people become one.

Remember this: The roles are important responsibilities and are not merely games. They will determine the future of Garden of Mirrored Flowers.

That girl would turn up at the swimming pool everyday at the same time as him, and would always swim in the opposite direction towards him. Whenever they met at some point when crossing the pool, he figured that she must be able to feel the ripples emanating from his center of gravity gently caressing her skin. Yet she never once turned to look at him, instead focusing completely on swimming.

He Shan liked diving into the pool to look at the frills on her swimming costume gently undulate like jellyfish.

The more he looked at her, the more he felt that the swimming girl was suitable for the role of Lian Jinfeng.[18] If she wore a

18. In *Flowers in the Mirror*, Lian Jinfeng (廉锦枫) is a fairy who descends to earth. Because her mother suffers from some deficiency illness, she must consume sea cucumbers often in order to help relieve her condition. Hence, Jinfeng vowed to master

glistening leather top and trousers, was bound and left standing at the corner of the ship, just like in the story, so that guests could pay up the ransom and save her, whilst a group of beautiful mermaids swam around the ship (even flicking their tails against the water and singing), it would be such a surprise for the guests.

As if responding to his imagination, she suddenly leaped out of the water, her face looking upwards, her lips parted, as water droplets glided down her smooth and flawless skin—it was as if she were waiting to be kissed!

Light reflects differently through the ripples at different parts of the swimming pool; the different speeds of light rays follow their individual rules as they merge or split, thus creating a vacillating effect on a body in water such that you can never tell where it is for certain.

The design of the waterway will undoubtedly implicate a sort of dramatic parabola in the experience process, moving according to the novel's beginning, development, climax, and resolution, the highlight being that of Little Penglai's Qi Hong Pavilion.

Moreover, the design of Pu Du Bay is of utmost importance: it will be a harbor entrance that gives people a sense of clarity as well as the beginning of an end, thus indicating the coming of an even more simple and pure realm.

The house on the hill afar appears as you strain to see as far as you can;
the pensive, deep bamboo woods are still captivating.
It is relaxed and breezy up above, with no neighbors around beyond the windows;

the water element, and would crouch each day in a large tank filled with water. After a long period of time, she trained herself to remain underwater for a whole day. She then dove into the ocean often to collect sea cucumbers. However, one day, she was captured by fishermen, and was kept bound on the boat to be sold later on. Fortunately, she was rescued by Tang Ao. Her true body is that of the narcissus fairy, and is henceforth nicknamed "Ling Po Fairy."

The vast ocean stretching thousands of hectares
basks in the brilliant illumination of the late afternoon...[19]

Guests can see different sorts of intriguing lands and scenery along the waterways, and all of these will be presented in a manner that exceeds ordinary day-to-day experiences; one would need to experience this space personally in order to understand what it is like. We can say that participation is the quintessence of experience.

In order to differentiate the Road of Sense and the Road of Sensibility, we have designed the following project lists with experiential items:

1. Aspects within the "Sensibility" Experience:
1.1. Gourmet Food

Wu Chang Country will be a kingdom of gourmet food, and will offer delicious specialties from all over the world via the buffet format.

Yuan Gu Country will specialize in providing seafood, where guests can personally go fishing or trawl for fish in the artificial lake, and then savor their catch immediately thereafter.

Tian Mu Country will be a feasting ground for fruits and its atmosphere will be permeated with the fragrance of fruits in season, whilst dancers from Baiguoshan perform for guests.

1.2. Music, Dance, and Carnivals

"Silkworm Girls," clad in their silk costumes, will dance at the periphery of Jing Ren Country.

Cockfighting performances will be staged at the boundary of Bai Min Country, and within the land, we will have a famous fashion designer create a special runway show entitled "WHITE WORLD SHOW," featuring porcelain white beauties crossing an overhead bridge in front of a pure white background.

Within the Country of Two Faces will be a masquerade carnival; Qi She Country will be a land of music from around the globe,

19. Taken from a section entitled "Garden Speech" in Ji Cheng's *Yuan Ye.*

showcasing all sorts of folk music worldwide, as the musicians need to guarantee their "distinctive native quality" with their performances.

1.3. Health and Beauty

Bo Lu Country will be equipped with traditional Chinese accupressure and medicinal facilities, to ease away any sense of anxiety and stress that people have.

The Country of Women will have a "Cosmetics Central," providing specialized cosmetics and beauty spa consultations as well as live demonstrations, and will feature youthful Russian girls as accompanying dancers.

(Proposal as follows)

2. Aspects within the "Sense" Experience:

2.1. Traditional Culture

2.1.1. Lectures on Cultures

Within Hei Chi Country, lectures and discussions pertaining to traditional Chinese culture can be organized, with all of them hosted by beautiful women.

2.1.2. Knowledge Quizzes

Riddle competitions with prizes for winners will be held in Zhi Jia Country.

2.1.3. Traditional Craft

Traditional craft demonstrations will be held at scenic spots including Gu Tong Stage, Wen Xing Chamber, Bai Yao Orchard, etc., to allow guests to understand the creative and manufacturing processes in traditional craftwork better.

2.1.3. The Art of Tea

A special region focusing on tea appreciation will be constructed within the fairy island of Little Peng Lai.

2.2. Psychological Consultation

A "Dream Analysis Counter" will be installed within the Country of Noblemen to help relieve anxiety that people living in contemporary times are plagued with.

2.3. Survival Philosophies

Shu Shi Country will extend special invitations to experts in strategies and philosophies of success to conduct lectures and discussions on related philosophies.

(Proposal as follows)

These myriad items will combine and collectively become a solid experience with multiple levels—from entertainment experiences which the guests are motivated to become part of, to engaging experiences exploring beauty and aesthetics, to educational experiences. These will permeate one another and form a unique personal encounter for one and all.

At one juncture whilst He Shan was documenting his thoughts in a flurry, he drew his view back from the flickering computer screen and turned his attention towards the gray horizon beyond his full-length glass window. The evening sun was casting a gradual and feeble smear of light onto the ominously thick layers of clouds. Skyscrapers were lined one after another, clustered like self-propagating cells that were frantically duplicating themselves and stretching all the way into an infinite nothingness. These mingled with one another to create the boundaries of our world.

A city that is constantly destroyed and then rebuilt, history that is repeated time and time again, until finally everything is murky and we can no longer see anything distinctly.

He typed on the keyboard. Before an ever-changing colorful background, a 3D model of Garden of Mirrored Flowers appeared, shook, rotated, came together, and then dismantled itself.

Notes on Meng Yuan: Dream

Sometimes I feel as if I am traveling through the gardens of my memory. Or I am walking through the garden that I have committed to my memory. Everything in the garden radiates a fragrance that is disconnected from the world. Temporal joy seems to have congealed in the atmosphere. I feel as if I had never grown

up, or should I say, I had grown up since the beginning. There is no essential difference amongst everything in this meticulously cultivated landscape. My father had constructed his ideal garden, and this garden has become the one in my memory. I will see your past, his future; it is only that I do not have the means to describe it at this point in time.

He Shan drifted off to sleep.

The earth was pitch black. I was on my own, slowly sucking in the darkness. My underdeveloped spine started to unfurl joint by joint, and like a tiger prawn shedding its shell, I could feel the excruciating pain as I stretched out. They buried me in the pine woods. That was winter. The roots of trees around me seemed to hit vaguely at something or other to me; they reached deeper and deeper into the earth and sought sustenance, while I was forced to be discarded by the living world.

As spring arrived and flowers began to bloom, I gradually understood everything from the past, and began searching for that cruel father. My cries came from deep within the earth (I could sink in deeper yet), coursing through the renovated luxurious teakwood flooring, across the surface of marble tiles, until they reach your bedroom.

Father, can you hear this?

He Shan woke up in the middle of the night from his dream, completely drenched in perspiration and with a continuous ringing sound in his ear. The walk to the bathroom seemed unbearably long, and his body shook from the cold marble floor under his feet.

He quickly returned to his bed and switched on the television with the remote control. The lurid colors onscreen pierced right into his eyes and made him shut them intermittently. His appendix, stomach, and nerves squirmed feebly. He swallowed his saliva a few times, trying his best to hear what was being said on TV: chaos on the streets, retrenched workers demonstrating for jobs and against globalization, tried to break through a police barrier,

thus causing a commotion... He suddenly felt a sense of relief from his responsibilities: the problem of the kid was finally resolved, and just like that, with the blink of an eye, a life was conceived and destroyed.

As the TV began emitting static sounds, he flipped to the last page of *Notes on Meng Yuan*:

After my father's death, I had a solitary stroll through the alley. The fallen leaves brushed softly against the soles of my feet. I could smell the decay of the woods in the air. I thought: if the plants in the garden were free to grow wildly, and the fallen leaves were left to accumulate, what would become of the garden?

My father did not turn into a rabbit. And I can no longer walk out of this garden.

As winter drew near, He Shan also seemed to lose his inspiration for Garden of Mirrored Flowers.

He hid away in the warm office and stared at the gray sky. He thought of that empty swimming pool in the small yard. The same southern breeze blowing little creases onto the droplets of dirty water in the pool also struck against the full-length glass wall and emitted sharp jangling noises.

He stared blankly at the 3D model of Garden of Mirrored Flowers manifesting itself on his computer screen. For a second, it felt like the end of the world.

When he returned to the construction site, he could feel an acute sense of futility augmenting within him. Perhaps it was a result of the contrasting joy of the imminent completion of work.

The mechanical arm of the bulldozer extended steadily and thrust itself into the heart of the earth. From the hilltop of the future Little Peng Lai, he could survey the entire work site: the outlines of the winding waterways had begun to appear; the civilization's building which resembled an octopus was having its wave-like alloy roof constructed, and it gleamed and shimmered under the sunlight. The whole construction site possessed an expansive epic

feeling, as if it were only during this era that so much energy and strength could be condensed to build a new Hanging Gardens of Babylon.

He Shan began to believe this: historical wonders of the world had indeed existed; they would disappear and then manifest again a few thousand years down the road, in a completely new guise. What was certain is that Garden of Mirrored Flowers was that sort of historic construction—*the mountains dance like silver snakes, and the highlands charge like wax-hued elephants, vying with heaven in stature.*[20]Everything was predestined to be realized in this space and time.

The stimulation provided by the bulldozer worked to stretch the new horizon unceasingly ahead.

Somewhere along the line, he found Xiao Ping standing next to him.

"Is history made like this?" She seemed to be mumbling to herself, but her tone sounded like a reproach for He Shan.

"It's so profound," He Shan replied.

He did not even turn to glance at Xiao Ping. If he continued to respond to her, then those previous altercations about *gender struggle and class differentiation within the park, as well as the deep regret over killing a new life* would swell up instantly like the tide and drown the both of them. He felt suddenly attacked by anxiety, and the stench from the distant industrial development

20. Taken from Mao Zedong's (毛泽东) famous poem "Qin Yuan Chun-Snow" (沁园春·雪). The full poem is as follows:

A Northern country scene: a hundred leagues locked in ice, a thousand leagues of whirling snow. Both sides of the Great Wall, one single white immensity. The Yellow River's swift current, is stilled from end to end. The mountains dance like silver snakes, and the highlands charge like wax-hued elephants, vying with heaven in stature. On a fine day, the land, clad in white, adorned in red, grows more enchanting.

This land so rich in beauty has made countless heroes bow in homage. But alas! Qin Shihuang and Han Wudi were lacking in grace, and Tang Taizong and Song Taizu had little poetry in their souls; and Genghis Khan, proud son of heaven for a day, knew only shooting eagles, bow outstretched. All are past and gone! For truly great men, look to this age alone.

site: *I can't find her anymore, unless I wait till next year's summer, when she will once again appear in the water, with her head raised, and that classic unchanging expression as if she were waiting to receive a kiss.*

The unfilled role of a particular fairy was, for him, almost a mortal void in his life.

It was at the "Crystal" desserts stall near the Survival Club that he last met her. Neither of them can remember too well what was said then. The one thing that stands out in his memory now is a feature article like this: her lips pulling back sharply upon contact with that pink-colored ice-cream, and then very rapidly swelling with an incredibly vivid hue, as if they were particularly made for melting, for separation...

Both of them kept silent, fully aware that all people and characters are pale and wan, and no conversation could alter the future. There is no need to escape, no reason to bicker. The easiest thing to do was to act as if nothing had happened, and to continue on the orbit of his or her life.

At the precise moment when the pink ice-cream melted in the mouth, he felt like capturing and freezing his life up to that moment, to accompany that moving song he kept locked up in his memory:

Since I met you by the river of tears
It is as if a spring breeze has drifted deep in my heart
I want to tell you softly
Please don't forget me

Since we bade farewell by the river of tears
I have been hiding so much pain in my heart
I want to tell you softly
Please don't forget me

How cruel, the autumn winds
That blow down the maple leaves

We still have our youth
Why retreat and fade into despair
Ha, life is but a dream

Since we bade farewell by the river of tears
I have been hiding so much pain in my heart
I want to tell you softly
Please don't forget me

Addendum in 2050

The objective of the following addenda is:

To prove the historical value of Garden of Mirrored Flowers as well as my innocence to one and all.

To confirm, through factual evidence, that everything had been progressing in the right direction.

To let everyone know that should there be no tomorrow for us, then it will be the same for people of other cultures and races in other parts of the world.

Just as the author George Orwell had prophesied about 1984, in 2050, after much arduous hardship, Newspeak has eclipsed and replaced Oldspeak (or what was previously known as standard English). As a result of the push of globalization, the Newspeak revolution is bound to influence the usage of language in our country as well; the entire world will witness the "Wave of the Newspeak Revolution" and China will certainly not be excluded from this.

Corresponding to Orwell's description of the three main types of vocabulary terms in Newspeak, Chinese language's Newspeak vocabulary can also be categorized into three groups: Type 1, Type 2, and Type 3 words.

Type 1 words are phrases that are used on a daily basis. They are basically made up of about one thousand commonly used words, and their meanings are extremely clear-cut. This type of word is only used to express one single, clear concept, and is not used in literary, political, or philosophical discourse.

Type 2 words are phrases that have been specially composed for use in politics. These tend to be language abbreviations, and are much more refined than common vocabulary. Those who do not possess full understanding of a country's policies will be unable to accurately utilize these words.

Type 3 words are supplementary phrases to the aforementioned two other types of words, and are purely scientific and technical terminology.

Like the "One Country, Two Systems" policy,[21] our country had already formulated the language policy for the interim period: the central principle is to "speak anew," and the slogan is "The sixty-year-old is in line with the thirty-year-old, the thirty-year-old is in line with the three-year-old," with the aim of eliminating Oldspeak by the year 2050.

Just as Orwell had predicted, "When Oldspeak had been once and for all superceded, the last link with the past would have been severed. History had already been rewritten, but fragments of the literature of the past survived here and there... In the future such fragments, even if they chanced to survive, would be unintelligible and untranslatable." At the same time, "the special feature of Newspeak will become more and more evident—its vocabulary

21. The "One Country, Two Systems" policy was originally proposed by Deng Xiaoping (邓小平) in the early 1980s during his term as the leader of the People's Republic of China (PRC). Its purpose was that of the reunification of China, where Deng suggested the possibility of having one China, but with areas such as Hong Kong, Macau, and Taiwan continuing their own capitalist economic and political systems; China would continue with its current "Socialist" system.

becomes smaller and smaller, the meanings of words more and more rigorous, and hence inappropriate usage could become less and less."

The development of Garden of Mirrored Flowers as a declaration of world culture and heritage and Chinese Newspeak's popularization are synchronous, and everyone had always been optimistic about these efforts.

When I was last at Garden of Mirrored Flowers conducting an inspection, I watched the flames at the city entrance cast a red hue over the intoxicated garden. People seemed to have been waiting for this day. The timberwork of buildings burned with an astounding speed; the Mongolian cavalry had already obstructed any way to put out the fire...

I hurriedly wrote down the following lines on a thread-bound book that was being destroyed by the fire:

Ancient people had sleepwalked in Hua Xu's Country with everyone having fun but now fallen into a pursuit of recollections and despair which is unlike Hu Xu's dream at all.

The way that the flames consumed the corners of the papers was so beautiful.

There was no prior indication of Kublai Khan's cavalry when they marched into the city. During countless idle chats on the meadows, it was said that the city had always been the sacred place that all men aspired to in their hearts; the bustling streets and delicate, lively Jiangnan women were like mystical beckoning forces, igniting their fighting spirit.

The only way to gain resources is to conquer.

Yet, history has proven that it is impossible to conquer the world by simply relying on military force.

Garden of Mirrored Flowers and its elaborate spatial architecture had stimulated our ethnic pride.

Once, I had personally seen a professor (who would get emotional whenever he talked about ethnic feeling) sigh in admiration as he experienced what Garden of Mirrored Flowers had to offer: aside from our extensive inland civilization, we also have a profound oceanic civilization.

This is enough to make Garden of Mirrored Flowers an important base for the education of history.

We can accomplish the best in our work only by fully comprehending that we are participating in the creation of history.

Once we recognize the significance of that, without a doubt, the success of Garden of Mirrored Flowers will become more and more of a priority for us.

What Garden of Mirrored Flowers had proven is this: in the swirling currents of the river of history, our countrymen's understanding of happiness has often been linked to either the vascillating fate of our ethnic group, the prosperity of the nation, or the harmony within our daily lives.

Happiness
Merriment
Pleasure
Enjoyment
Looking for happiness
Eliciting happiness
Delight
Optimism
Happy earth
Amusement park

All the above phrases will be replaced by a Type 2 phrase: *New*

Collective.

New Collective already contains the meanings of all the afore-mentioned words.

[New Collective Activity] Let us view K Company's chip assembly line through this four-hundred-meter-long organic glass wall, just as we would gaze at the beauty of sea animals in an aquarium. The all-female workforce move their hands like seasoned machines with precision and skill, their fingertips gently brushing across the circuit boards as they press in all sorts of tiny spare parts, their eyes unblinking and never directly looking at us—we are all similar in type—as we look at them.

At this point, I suddenly felt like touching their hands, or having their fingertips—aglow due to their work—glide across my body. These are my fellow citizens, these are us. I stared at the back of one of the young women workers, and could feel her body heat, projected onto the speedy line of chips, mercilessly aroused my state of joy.

Those questions that perplex with their tangents should give a standard model answer once and for all. This is precisely the significance behind the Newspeak movement.

Of course, some memories can serve as proof of the correct way of living by demonstrating the contrary:

I hid in a corner of the theater, looking at the man and woman making love on screen—they were telling me that this was how I was created.

It is only in the cinemas specially opened for "migrant workers" that I would have the opportunity to see such primitive images; this place would always be an ignored spot in the promotion of Newspeak.

Oddly enough, it is only in that space that I can taste what it

is like to be carefree; that is to say, a place where the individual has yet to find his position within a collective, where he has yet to assume a heavy responsibility in the organization, where a forceful sense of direction has yet to manifest itself to dictate everything in life.

These movies made me fantasize about some chance encounters.

Thankfully, these chance encounters have not happened before.

And I have finally grown up to be a person that is worthy of being relied upon by the collective.

I thought about a child that was recently reported on in the newspapers, who, when asked by his mother what he wanted to be when he grew up, cocked his head sideways and replied, "I want to be a computer."

Such a response warmed my heart and filled me with confidence in the future.

I could always discover different historical facts and their profundities each time I went to check on Garden of Mirrored Flowers. This made me firmly believe in the objective historical nature existent within Garden of Mirrored Flowers:

Dense human traffic and smog
High-rise buildings (even then, this was already a high-density city)
Riverways (showing the city's spatial layout)
Fire-retardant, anti-theft warehouses—the epitome of government organizations
Currency: Banknotes
Merchant: Moving and Migration
Slum: Assembly point for the rural labor force
Early Capitalism
Struggles between labor and management
Songstress: Entertainment

Private Gardens, fish
Temporary palaces
Banquets
Astrology and fate
Marriage and allies
Tributes and safety
Human body and traditional Chinese medicine
Prescriptions
Heavenly Stems and Earthly Branches
Dawn (the topic is mainly on how to recover the northern territories that have been usurped by the nomadic tribes)
Festivals
Gods
Buddhism
Mass entertainment industry
Storytellers
Non-governmental organizations
Private publishing house
Song Dynasty poetry
Landscape paintings

Despondency and disillusionment
Imbalance in the nervous system
Non-governmental aid agencies and "Early Socialism"
Food and rental class: A new type of human being
"Waiting for the costly to become cheap, equality for the rich and poor"
Transparency in capital control
The drifting generation
Buildings for charity
Ancient remittance services
The prevalence of luxury handicrafts
Sailing
Marco Polo
The Floating City
Early Air-Conditioning Systems

At that time, there was already someone writing a new edition of *The Analects*, which later became the widely circulated *Confucian Capitalism Classics* (论语).

Similarly, the archeological process of Garden of Mirrored Flowers is that of restoration to its original form, in order to demonstrate the significance of our national cultural history to world civilization.

Today, Garden of Mirrored Flowers cannot help but be a paradise for the people, and this is in line with its initial objective as an investigation into dialectical materialism—it has finally become an important base for the teaching of Chinese history.

Once, when I was inspecting the park, I spotted from afar the backs of two young people by the lake. Amidst the floating catkins of the willows, I heard this dialogue between them:
"Do you know what has happened out there?"
"What?"
"A revolution."
A burst of laughter.
"Revolution for what?"
"A revolution for our own lives."
The girl smacked the boy lightly.
"Don't joke about revolutions."

If a person can constantly revise his life—just like a book that can be reprinted and republished at any time, with a few addenda here and deletions there, constant adjustments of the sequence of page numbers, amendments of typographical errors...

then, everyone must know that now is the time for correcting all mistakes once and for all. Through the Newspeak movement, we can rediscover the true relationship between words and the world.

On New Year's Day, I took part in Garden of Mirrored Flowers' annual celebrations. There were many guests around the altar, and a total of 1,888 torches were lit all around the venue. These extended like tentacles alongside the buildings, creating a somewhat mystical atmosphere.

I bumped into Huang Xiao Li under the statue of the Goddess of Mercy—she was one of the new generation of architects charged with supplementary projects or "auxilliary projects" for Garden of Mirrored Flowers.

With her directions, I managed to arrive at the model room of the "auxilliary projects," and finally had the opportunity to savor each detail of their work meticulously: the main construction was an oval multi-level building, forming a spiral from large at the bottom to small towards the top, akin to the vertical section of a cochlea of the inner ear. I reckoned that there were countless other worm-hole like passages within the building. The oval-shaped pipeline on the ground level extended towards an even more complicated group of buildings. From my viewpoint over here, these resembled the innards of an octopus, with a central construction stretching out like tentacles in a radial formation, extending towards mountain ranges, islands, and waterways. What was strange was how the structures stretching towards the waterways seemed to be absorbed into and smoothed over the water's surface, such that you could not see any trace of their disappearance. These antenna-like structures possessed an exceptional sense of gentleness, and I was tempted to touch them myself.

My senses seem to have once again recovered their keenness. Perhaps this is what is called the **moment of realization**; perhaps someday in the future, I will understand the cause of everything:

life's serendipity, the body, space, history, others, everything about the world on land and under water.

When we walked out to the hall, fireworks pierced through the night sky, each carving out its orbit like a comet, with the spectacular illumination reflected on the wave-like alloy roof of the altar.

"The festival is about to begin," Xiao Li reminded me softly.

As I looked at her face and lip line which were tinged a vibrant red by the fireworks, I thought of the skin of the suckling pig that was being roasted at the altar, and suddenly realized how beautiful she was.

May that delicious little suckling pig herald an even more wonderful future for us.

I could sense that people would once again lose themselves in this park that was expanding unceasingly, in fragments of fissured words, in the embers of memories and the routes forged by curses that could come true.

Yet, Garden of Mirrored Flowers' life will accompany our own, continuing and extending onwards.

That night, I had the profound realization that if there were no tomorrow for us, then there would also be no tomorrow for other places and other people in the world.

Attachment:

Silent Theater (II)

A Director's Notes

When the earth is viewed from the moon, this incomparably wondrous sphere is seen suspended in mid-air, surrounded by utter darkness, illuminated with a slight blue florescence:
Like a spirit sound asleep in the bedroom at night.
Like a candy that has not yet been wrapped up, lying naked under dawn's first light.

I have seen them walk past previously I have seen countless people walking by my viewfinder, but have gently abandoned them all.
Unlike a novel which is written, directed, and performed by the same person, a film differs in that it is answerable to a number of people. Both film and societal living are exceedingly similar in that both involve the art of compromise.
Why can't the film director write a novel instead? Then he would only have to be responsible for himself and the words knocked out of the keyboard; he could skip as he wished among thousands of characters, bounding between the fluctuating lives of you and me and whoever else.
Then, I saw her appearing through the morning mist, just like Venus manifesting herself under Botticelli's brush as she emerged from the water. In my memories, youth only retained remnants of some young girls' scents and fallen leaves in winter, and those gigantic slogans and admonishments of my elders have long been forgotten—or rather, they have been reincarnated as demands of investors and pastimes of the market, both of which have, strangely enough, integrated with the most fragile and beautiful bits of my memory, thus creating an embarrassingly named "Post-Socialist Aesthetic Narrative" sort of thing. We are still continuously excavating deep into our innermost

selves to discover that melodramatic, sad plot which can then be sold; we are doing our best to keep up with the times, to once again create some epic personal narrative that surpasses the grandiosity of history.

Sometimes I feel that on a material level, a book might hold more meaning than a film production. A book—as long as it is a good book—has the implication that on some particular morning, through that same book, everything before one's eyes could suddenly seem more lucid and definite, as if life could once again be touched rather than lapse helplessly into the nondescript.

Yes, you don't have to make a special trip to the cinema, stand in line, buy a ticket, bear with the crackling of nuts being munched by your neighbor in the next seat, endure the end of the movie, wait for all the lights to come on, then experience that instant of disappointment as you return to reality.

The disappointment that is akin to the one you feel at the very moment you arrive at the destination of your travels.

Her: Journey

At this moment, she is sitting on the flight that lets her flee from her homeland.

According to the rules of the airlines, each passenger can only bring the following items in their carry-on luggage:
- *1 women's handbag (or men's briefcase)*
- *1 overcoat or raincoat, or 1 travel blanket*
- *1 small camera and 1 small pair of binoculars*
- *A small amount of reading materials to be used during the flight*
- *Wheelchair for disabled passengers, 1 walking stick or artificial limb*
- *Baby food and 1 baby cot to be used during the flight*

Aside from the aforementioned items, all other items are to be placed within the check-in luggage and are to be handled as per ticketing rules with regards to weight limits.

As the plane flew through layers of clouds into an even more limpid and clear blue sky, she became captivated by the beautiful clouds

appearing under the plane, in various permutations of shapes and sizes. Tens of thousands of meters under those clouds lay the hometown she was fleeing from. Just like a thousand other nondescript Chinese towns, it was, to her, collective space from which she was totally disengaged and dispassionate about; her family and friends staggered along as they tried to ascertain their place in life, and she could only fly into the sky. Some people have said that the truly fortunate ones are those on the ground.

Because we can see the blue sky
We have become the helpless retrenched ones

The voice of the blind singer Zhou Yunpeng (周云蓬) played and lingered in her head (he really looked like one of her classmates from secondary school).

Is this what it means for her to be waiting for her fate?

Him: Airport 1

He detested having to pack his luggage before departure. It made him feel as if he was forced to close a chapter of his life, or that he was forced to toss out a portion of time from his smooth-sailing life.

This anxiety would persist until he finally arrived at the airport. In some ways, the interior of the airport was just like a cathedral, with its arched ceiling decorated with crystal-like items, creating an atmophere within which he could numb himself. The architect must have had a profound understanding of the relationship between an airport and a cathedral.

One could always find **meditative spaces** in the ever-growing cavern of the airport; for instance, in the huge elevator, the ceiling lamp which suddenly comes on evokes the idea of a sudden spiritual glow.

The waiting time during the journey had almost become his way of extending longevity.

Each trip, aside from bringing Tom Peters's *Liberation Management*,

he would bring another book, *The I-Ching*, since these would be such unpredictable journeys.

A Director's Notes

I often think that perhaps the story has ended at the very moment the plane touches down.

Your luggage lies idly on the conveyor belt and revolves around aimlessly, like a forgotten item drifting in running water. The suitcases wait dumbly for their owners to reclaim them, yet the owners are lost among the crowds.

Subjects, scenes—these seem to be so readily available in real life; there are always exciting human-interest stories in the newspapers everyday. Yet our anxiety festers in exactly this restless and unpredictable reality. Aside from the reliance on extravagant production costs to create visual stimulation, what other power does film possess which attracts people enough to have them seated quietly in the dark to engage in a dialogue with lives unfolding onscreen?

Real stories are often brought about between two places, two situations, two people; they are often produced within that state of opposing movements.

I had better use both my hands to create a simple viewfinder and focus on a man anxiously waiting for his baggage by the conveyor belt. About two hundred meters away at the exit of the airport, a woman stands opposite the glass panel waving at him.

Her: Dawn

In the office-bound human traffic at dawn, the young, radiant office lady swayed along with the train's movements. The reflection of the opposite glass panel was cast upon her face, making her girlish gaze seem even more hopeful.

This youthful city is nourished by the vitality of these young people. Yet it has never thought about their future: those thirty years old and

above will no longer be able to find work here.

In the southern summer air, she could once again smell that stench of ennui, eroticism, and fishiness. Too many years had passed, and she was no longer used to that manifestation of desire. The air was more polluted. Meanwhile, the dashed hopes and dreams of the young people were being transmogrified into a hand gesture on the waterways, a hawker's call in the fashion stores and the naïve dreams of the milkman.

The van was soaked with morning dew as it entered the city at dawn, as if it were perspiring after laboring for endless miles. On the van were fresh green vegetables and a hog that was just butchered.

At a bus stop situated at the intersection between the city and the countryside, she spotted a young woman clad in a black overcoat standing in front of a sign which said "Namo Amitabha." This haphazardly created cement sign was placed right below the bus stop signage. It was not clear whether the bus stop was a temporary one that had been built here, or if the sign was simply fated to be placed with this bus stop. The woman's demeanor made it difficult for anyone to guess if she was actually praying or waiting for the bus.

She suddenly felt like both of them were in the same boat.

Her: Body

Over here, she had been encouraged by various people to use her body as a sort of investment towards a new life. They said that this was the investment with the lowest starting cost, yet one which could guarantee returns. They added, this was also the fastest way to go.

The prerequisites for a body are so closely related to the development of a city, to the extent that these requirements originate from the city itself rather than from the people who live in it—the city requires these bodies as tributes to desire and lust. Of course, from a historical viewpoint, this is also the longest established necessity of man, and is one that has not languished with time.

Professional working women, that is to say, either those who work

in an office or those who use their bodies as their place of work, must give the same intensity to their work, and experience the same risks at their jobs. Perhaps the choice between the two is futile anyways.

When it was time to knock off from work, a number of huge mushroom clouds appeared in the sky as people made their sluggish journeys back home.

A young man and a girl smiled as they caught sight of each other on a crowded bus. She proudly stuck her newly developed bosom out. It was obvious that they were in love.

The colorful buildings by the river were somewhat inclined as the waters rose with the tide. It was obvious that nothing could hold their love for each other back.

Him: The Zoo at Night

He stood before the glass barrier and looked nonchalantly at the two giraffes moving around in the greenery, the markings on their bodies seeming even more obvious in the spotlight. A girl held up her camera before remarking, "Aiyah!" and putting it down again— it appeared she could not capture a view of the towering giraffes from her viewfinder. As he watched the giraffes nimbly lick up leaves from the trees, he thought of the circus act earlier where the Russian girl hooked her slim, long legs around the golden ring and hung herself upside-down.

The animals began to manifest themselves through the shroud of darkness, just like a set on stage.

He stood before the glass barrier, downing raw oysters as he watched the white tiger roam idly around the garden, its eyes occasionally meeting those of folks standing around before it would turn its head away in disdain and return to its cave. The tiger's rough, thick tail dragged across the ground and brought to mind its impressive power of yore. Yet now, the people around him continued to consume the food offered to them, as they planned for the next entertainment item

of the night.

A Director's Notes

With regard to how we can design an outstanding set, my good friend, who is a set designer for light urban comedies, once divulged the trick of his trade:

It has to be more extravagant than reality.

I came here because I was looking for an outdoor location for a period TV drama and a friend had recommended this spot. That was a village in the southwestern region, a somewhat far-flung location that was not easily accessible but which you could get to via a small three-wheeled motorcycle. The wooden stilted building was constructed against a mountain, and looked like it was growing right out of it. The villagers worked from dawn till dusk each day. There were singing assemblies daily, and their lovely, lilting voices were something I had never encountered in my life. As I faced the fresh, clear landscape, my mind was filled with ideas on placement of viewfinders, actors' positions, the flirting scenes between the lead protagonists as well as what the audience's reaction may be. A local government official from the area was chattering on about the developmental plans for tourism, and I responded occasionally, fully understanding that this was the reason for the warm welcome that our film crew had received. Meanwhile, the landscape before my eyes seemed even more pure and untainted, as if awaiting in all innocence for our conscience to prick while humankind continued to strategize how we planned to use it. Time, budgets, markets, camera shots—these were all forms of violence, and when violence is inflicted upon you, there will be no apology.

Her: The Small Town

When she returned home that time, she finally understood: the

scent of a woman's youth was a mélange of the fragrance of camphor wood and wild roses. Before the old, narrow alleys were torn down, the whole town was saturated with this air. Even the young hoodlum waiting outside the school gates had a few wild roses with thorns in his hands, arranged like a bouquet (they were waiting eagerly for the haughty, swan-like female students). At that time, she had yet to notice that the workers' theater that all the boys and girls wanted to go to was a typical "Socialist" building. The last time she was back home, she discovered that although its external structure had not changed, its façade had been replaced by a glass screen and it had been renamed "Starry Entertainment Complex."

As she walked through the small lanes, she felt she could even touch the traces of her first romance.

As you pass through this town at sunset, you find that people seem to be in a dreamlike state. The foreign girls appear much more haggard at evening because of work. You can see young chaps peddling DVDs of drama series and pornography everywhere. She was happy, like a child, because she managed to catch the right bus.

A Director's Notes

The city flitted through the curtains of night. From afar, the dim streetlights illuminated the uniform streets and dispersed human traffic. The rhythm of wheels striking against the railroad track added to the vast and empty landscape. As I withdrew my gaze from the scenery, I noticed my own reflection on the windowpane—I looked skinny, a scholar from ancient times, whilst beyond the window, the train tossed away the nameless streets, one after another as it raced through the night.

This sort of journey is best suited for reading a book like *Six Chapters of a Floating Life*,[1] while imagining the desolation of a

1. *Six Chapters of a Floating Life* (浮生六记) is a autobiographical collection of prose written by Qing dynasty author Shen Fu (沈复) during the thirteenth year of the Jiaqing period (1808) and was published and distributed in 1877. The words "Floating Life" were taken from Li Bai's(李白) poem "Account of the Spring Evening Feast from Plum Orchard (春夜宴从弟桃李园序)":

scholar exhausted by his travels, as yet unaware that his destination will also be the place where his beloved Yun Niang has died. He would think of the first blossoms of the lotus in summer, and how Yun Niang would tie a small portion of tea leaves in muslin from the mountains, before placing it within a lotus bud for the night; the following morning the lotus blossom would have imparted a mellow fragrance to the tea leaves, and when steeped in boiling spring water, produced a sweet, elegant tea. That thought made me forget about the stench of piss mixed with rust in the carriage.

Six Chapters of a Floating Life has a natural melancholy and beautiful storyline, and fortunately, it has yet to be adapted by the Koreans into a melancholy and beautiful drama series or film.

Him: The Barren Landscape

From Tokyo to Kyoto. The female ticket inspector on the Shinkansen moved swiftly with expertise from one passenger to the next, checking their tickets before expressing her thanks politely, all the while maintaining her intonation and cadence like an audio tape on repeat. Her entire body was compact and tight, in a mode of absolute self-control, each action meted out with mechanical precision. It was all a total contrast to the nonchalance and desultory demeanor of Chinese people in public.

Kyoto is a geographically flat city that is still lined with buildings from the Edo era. One could not help but imagine the Japanese people's self-circumspection and control (to the point of torture) existing in the tiny rooms behind the tightly shut windows.

A man of heaven and earth
Is but a traveler who passes by myriad lives;
A man of light and darkness
Is but a guest of a hundred generations
The floating life is like a dream
What happiness could it give?

He stooped to enter the meditation room in the Zen garden. As he knelt and observed the landscape paintings on the four walls, his viewpoint extended naturally beyond the room towards the barren landscape outside. Like Yin and Yang, both the paintings and landscape created a space where each complemented the other. The sense of distance that is so palpable in real space and time had completely vanished within this little universe, and the silence compelled him to question his own being, despite there being another voice which reminded him: this is only a temporary and pointless query, and you'll be back in the real world in no time. The corridor's shadow divided the gravel surface of the ground in two. On the top right corner of the rectangular stone courtyard was a pair of sal trees. The longer he stared at the two piles of stones in the courtyard, the more he became acutely aware of the passing of time. There were two rows of Kanji characters written on a wooden signboard on the wall:

Life and death are important events
That are impermanent and swift.

Her: Carriage

On the train traveling from Guangzhou to Shenzhen, she noticed the young mother sitting opposite her drift off to sleep and the milk bottle in her hand slide onto the seat, the milk spilling out from the tiny teat.

Life seemed to be about choices. She could choose to marry a man and have a child, and just as two blankets could be folded into each other, two lives could similarly be piled together like that.

Him: MUJI

The deep sea green of seaweed coupled with the whiteness of a rice ball have become part of his daily life's rhythm. The packaging on the Ito En green tea beverage had the winning entries of a haiku competition printed in distinct characters on it.

When he was at MUJI, the display television unit at the store

screened a video about the manufacturing process of a cotton carpet in a factory in India. The workers seemed indistinct, as if they were being filmed by a surveillance camera in a bank or an elevator. Some of them would peer into the camera from time to time, before turning their attention back to the work at hand.

Most of these were "Made in China" as he had expected.

A Director's Notes

The locations this time around were a number of abandoned office buildings.

Countless businesses have come and gone, come and gone through each of these office buildings, like the ebb and flow of waves brining different sorts of debris and remains of animals from the sea. Distinct partitions of office cubicles still remained in these deserted spaces, and there were traces left behind by computer desks, stationery drawers, and so on. The reception desk at the entrance retained the vestiges of the previous company's brand and name. As I moved through the terribly musty corridor and pushed open the metal door at the end, I caught sight of the debris of time arranged before my eyes, as if silently divulging their inevitable fates — all companies, and even their employees, will leave in the end. Walking through this derelict, slightly moldy space, I could almost hear the faint clicks of the high heels worn by the lonely office ladies strike against the floor.

Different companies are akin to different species. The remains of this building's species struggle like specters to be resurrected, and yet the best medium that can assist them in regaining their lives would be that of images — under my direction, a romantic office love story will unfold in this inexpensive location. Perhaps this is a way for me to grieve for the spirit of this city.

Her: Elevator

The endless corridor of the office building, the identical doors, which probably open up into identical worlds.

The only place where she could be alone was in the elevator after-hours and during non-peak periods.

When she passed through the damp underground tunnel everyday, or saw the people sitting opposite her on the public bus she rode to work, she would always be seized by the impulse to say hello.

Him: Wings of the Airplane

He could clearly see the water condense on the wings of the airplane, which then rapidly solidified into ice. Despite the chilly air, the passengers in the cabin were bursting with energy—someone began singing "The Steeds Racing to Protect the Frontier "; it was a cultural troupe embarking on a performance abroad. The plane was then gliding across the desolate and sparsely inhabited landscape of Siberia, and time seemed to accelerate gradually.

I have finally gotten used to sleeping on the seat of an airplane; I have gotten used to the airplane's slight rocking during turbulence, the bland in-flight meals which all taste the same, jet lag and time difference, different hotel rooms and their different smells, as well as a variety of foreign girlfriends who are as disposable as lanterns (these chance encounters on the road are little compensation for the immense work-related pressure I have to endure). No Saturdays or Sundays, with all my work being done on the road, on the road. I'm that "Man of the New World" that the media talks about—since September 11, 2001, the odds of being in danger while sitting in a high-rise office building as compared to being on a plane have pretty much evened out—the sort of person who relies on time difference and the speed of flight to score a victory; the sort of person who has the hotel as a home and his home as a hotel; the sort of person whose feelings are always noncommittal, for whom sex is merely an end in itself; the sort of person who is wedged between a developing China and the developed world, a parasite dependent on information and time. As I look at the aimlessly drifting clouds outside the plane, I often feel overwhelmed by an intermittent sorrow; as I glide through the night sky and am suddenly greeted by the twinkling lights of the city below, I think that

someday perhaps I will wake up to reality, like I had sworn in class when I was a child: **I want to be someone useful to society**. Wishes are as simple as that, and yet they are so difficult to realize because first of all, we no longer understand what it is that our society needs; and secondly, we are even more baffled as to what would be useful for our society.

In fact, each morning when I wake up, I get the sense that there are countless possibilities in life stretching out before me, and as long as I make some sort of a decision, then I could live a totally different life. However, I know that I would always return to that journey to work; that is a familiar road which is relatively safe, despite being one that cannot ignite my passion. Perhaps it is a slow road to suicide.

Her: Tree

She saw two trees leaning against each other in the damp night sky.

On a night imbued with rain and fog, you can even hear the call of the train's whistle from afar.

Him: Wife 1

Sometimes, he would feel his heart suddenly swell with a sense of intense emptiness. For instance, he was lying on the bed in the hotel room and all of a sudden he was consumed by a distinct feeling of himself **dying slowly right at this moment**; meanwhile, a British hostage was kneeling on the floor, pleading through the television for his government to save him, as two terrorists flanked him on either side. Their images were indistinct, as if they were broadcasting from a faraway desert without modern-day telecommunications systems.

Terrorists, like patients helplessly waiting for surgery from a hospital bed, are all people on the brink of despair.

Then, as if life was not already rife with humor, the phone rang. It was his wife, calling to say that she missed him. The ends of that telephone line were situated in different time zones, with different states of mind and levels of warmth. Yet, she disregarded these

disparities completely and chattered on about how she was feeling, with no regard for the fact that he had just crawled from the darkness onto shore.

"What's wrong?"

"Nothing."

He was too lazy to reply. If both parties could comprehend what the other was trying to say, then perhaps the situation would not be as dire as it was.

On the TV, the terrorists had placed an execution rack around the neck of the man, as if they were directors speaking while giving a demonstration.

A Director's Notes

Living in the gaps between cities.

The neon lights of the club pierced through the night sky. When you open the door, you will suddenly discover the existence of another world, one which is separated from the normal world by a mere door. The lights in this other world only come in black and white. As people in the club dance wildly to the rhythm of the music, waiters come up to you with a silver tray, which—if you look closely—has a slight trace of powder on it. Two young girls who are almost nude are fighting to tell you: it's 100% pure. No one asks where you come from; so long as you are here, everyone is a friend—the old chap who is missing some teeth keeps stroking your bare arms, you grab hold of two ladies nearby, as if you are hanging on to two life buoys on the wide open sea. I'm going to die, I'm going to die, you say, it's just a door, a second away from certain death. Despite the misty rain and smoke, our protagonist felt very happy to be still alive. He actually managed to get out, and on his way home, he began dancing on the roof of the jeep. The spruces by the road were bathed in rain and fog; this return to the normal world is so, so beautiful.

The city as an outdoor location:
Is the city destined to be the destination of the life of humankind?

Her: Bus Station

She could see the terminus for the light rail trains from her balcony.
Late in the night, the trains would pass through the public woods
nearby to return to the terminus for their slumber.

One train, two trains, three trains. Their exhausted bodies would line
one by one in repose, as they slowly regained their energy for the next
day's work.

She would find herself turning to look at the simple furniture in
her house, and would remember a story that she had once heard from
some place: two lovers who decided to cohabitate had mixed up each
of their beloved books, CDs, and clothes in a pile, just the way their
bodies had melded together.

Him: Hotel

The hotel's decorative columns were like a row of office girls
wearing well-pressed trousers, standing with their legs apart, the
shadows cast by sunlight reining in their secretive crotches like the
triangles of g-strings. He looked up aimlessly, seemingly shocked by
the nudity of this pornographic everyday scenery. Meanwhile, images
of the containers he had seen the day before at the harbor suddenly
flitted past his mind—blue, white, yellow—all moving in a flash,
while the large hanger continued rotating, even though the goods had
been delivered on time.

In this room which is charged by the hour, what should be an
episode of wild sexual frenzy instead took on a strange sense of
repression. When it was finally over, as he turned his attention to the
stuff strewn all around the room, he felt a deep sense of distaste and
dullness, and no longer had any interest in even glancing at her naked
body.

She was lying face down on the bed, and had become yet another
body without any relation to him. He preferred to begin packing
up all the items that could no longer elicit any sense of impulse,

and then head to the washroom on his own to begin cleaning them meticulously—for him, at this moment, the washroom had become a quiet space for meditation.

Her: Weekend 1

During the weekend, the short break seemed to add to her physical and mental exhaustion. As she moved from the massive shopping mall to the subway, she noticed that the train carriages were filled with people with tired looks on their faces. Suddenly, a young woman leaped into the carriage, holding up a red paper crane in her left hand, and a dark red crinoline of a nightgown in her right hand, and sat down opposite her. The wind current from the ceiling air conditioner blew onto the crimson red wings of the crane, which flickered as if making to fly from her hand. At times, the girl would scrutinize the crane as if she was ruminating; at other times, she would lay her head on the backrest of the chair, as her face slowly lit up with the trace of a smile, which seemed to brighten the dark carriage.

Is that the post-coital smile of satisfaction?

How long has it been since I've felt that intimate touch of skin? She directed her gaze at the shimmering, distinctive texture of the gown; the reflective fabric seemed to be trembling slightly, as it groaned ever so weakly.

Her: Weekend 2

The bus passed through the dusty road in the sun. There was a pair of twins whose feet had yet to reach the floor of the bus when they were seated. They stretched their necks out of the window to look at the bare and dazzling road.

A young chap asleep with his head leaning against the windowpane, bobbed along with each jolt of the bus.

That old man had prepared a circus clown's costume himself, and was performing as he did each week at the cultural park.

A pregnant lady wore a red-colored wide dress, as if announcing a red alert to everyone.

An ice-skater was working hard at her practice. She spun around, dressed in a multi-colored T-shirt and black tights. At that moment, she was at her purest and most lovable state.

I am still almost a virgin, she thought, and felt somewhat aggravated by that.

Beside her, a boy passed his earphones to his girlfriend, so that she could hear his favorite song.

At dusk, the travelers could not find their way back. The locals decorated their own homes with bright lights, in a bid to dispel the loneliness.

A Director's Notes

Our protagonist arrived in Amsterdam at dusk. Looking at the fiery sunset, he could not help but think of one of van Gogh's later works, *The Starry Night*. He stepped into the gigantic industrial elevator, and was hoisted up to the top level of the old post office building where the restaurant was located. Night had already descended. The train speeding towards Central Station resembled a freshly lit match from the view up above, and he watched it gradually vanish into the tightly meshed capillary-like network of train tracks.

When he went to the bathroom in the middle of his meal, he accidentally pushed open a wall. In fact, it was a door partition that resembled a wall, which opened up to another world altogether. The space was throbbing to the powerful beat of the music, and people were standing around various small tables, heatedly discussing something or other. The atmosphere seemed to be filled with some sort of colored mist. Everyone's gaze was fervent yet somewhat absently fixed upon the person they were speaking to. He had to weave through the crowd to get to the bathroom.

When he returned to his seat, there was a young man by the table, saying something agitatedly with his Dutch friend. As he spoke, the young man stooped to kneel on the floor. "I kept deleting, deleting,

deleting," he said as he waggled his forefinger, rapping against the floor, indicating his rapid tapping of the mouse button as he deleted the files. "Another friend of mine is the founder of this social networking site," he swung his head quickly in the direction of the wall. "He is completely different from me; he would accept anyone, and right now, on his friends list, he's got about 25,000 names, and they keep increasing by the day. But me, I delete, delete, delete." He repeated the hand gesture. "Yet at the end, there were more and more people who wanted to meet me. This is a strange world. When you beg others to meet you, there's just no way in; when you don't give a shit about them, they will look for you instead."

It was very late by the time he returned to the hotel. Although it was already June, the wind was so strong that the windows kept ringing with the huffs and puffs of the gusts. He turned on the pornography channel and was awash with a sense of relief: it was much better watching these flicks in a comfortable room than to wander around the red-light district while bracing against the cold winds. He fell asleep in a daze, accompanied by the moaning and groaning from the TV screen, with the remote control still in his hand.

Him: The Future

The small raindrops against the windowpane of the vehicle slid down towards the edge of the glass according to the direction of the car's movement. Initially, they were slow and tentative in their trembling; then all of a sudden, they would suddenly accelerate and be drawn by gravity downwards. Each raindrop would hence became a slanting liquid trace and the lines would gradually merge and intersect, forming a living, moving map replete with routes. Each raindrop would repeat the same process, from spot to line to surface, then go through the same thing all over again.

The car flitted through the rain and fog, past old apartment blocks for senior citizens. The corridors of the apartments were directly facing the outer ring expressways, which were empty on the upper levels. It was hard to imagine an old person having to gaze at the cars on the expressway and the faraway lonely hills as his only way to pass

the time. Yet, the design of this famous apartment for senior citizens was precisely that; the expressway lies just at the door and the hills right at the back, as if to make an allusion to the saying: the city lies before us, with the coast behind us should we return.

It would be best if it were like the stock market, where the future forever remains at some upsurge within the expected period.

Her: Place

She would rather be born in a place that cannot be located on a map but yet still exists.

The moment she enters the door and sees her parents, she would come to the realization that all her dreams cannot be found within this home, and that she would have to leave as soon as possible.

She lies on the small bed prepared for her by her parents and thinks about last night's journey and that impulse she had to masturbate. Through the walls next door, she hears her mother's sighs, still immersed in her grief over her grandmother's death. (If her mother passed away, how deep would her own grief be?) Her grandmother had gotten up in the middle of the night to turn on the radio (she liked waking up at night to listen to the radio), but had slipped and fell, and never regained consciousness after that.

There was one bitterly cold morning before her grandmother's death when she had lost her way ambling around the area on her own. The precinct's security guard had telephoned her mother, who went to bring her grandmother back. After that, her grandmother no longer dared to leave her room at all.

She browsed through the old books that her grandfather had left behind, smelling that somewhat mildewy scent of the books. She spotted the following line in *Yan's Family Teachings*:[2]

2. *Yan's Family Teachings* (颜氏家训) is a work written by Yan Zhitui 颜子推 (531-591 AD), detailing his thoughts, experiences, and knowledge as a means of teaching. It was completed after 589 AD, became a core educational text on traditional Chinese society and marked a precedent for future "home teachings" that were created.

The less lives you kill, the more you can cultivate your soul.

She could hardly imagine how it would be to live with her parents in the long term.

This was like a particular forlorn afternoon she remembered from her youth—the sunlight outside was radiant, yet she had no idea how to live through the day.

Her: Meeting

They met on a rainy day like this. He had coincidentally sat down beside her. They passed by bus stop after bus stop, and there were fewer people remaining on the bus. They were still seated beside each other. Occasionally, the skins of their naked arms would brush gently against each other. His eyes were focused on the indistinct street view beyond the window, when he suddenly plucked up his courage and asked, "Excuse me, but where are you going to?" He dared not cast his eyes on her as he spoke; his voice seemed to be almost drowned by the rumbling of the moving bus.

Him: Meeting

Her message to him on MSN said, "I'd once fantasized that you were mine."

She and he met each other online. After a few chats, she found herself attracted to his experiences and way of thinking, and began to send photographs to him.

He understood that this was a pursuit of a sense of security. As such, he did not give any promises and kept the relationship on a nonchalant, easy-come-easy-go basis.

Our lives are all salvaged
Then let's
Be unrestrained

He replied in this way casually, and then turned off his monitor. Just like that, she vanished into an endless black hole, like the genie servant within Aladdin's lamp. He suddenly snorted derisively as he thought about how naïve her request to meet in person was.

Him: Passageway

He met someone at Starbucks who shared the same interest in technology and use of terminology, someone who read *The Wall Street Journal* and *The Economist* like he did.

An old classmate he was not close to remarked sarcastically, "You people, no matter where you are, your life just revolves around you in this small circle, and you're just looking for some false sense of security." Yes, that is a necessity for survival.

That old classmate would never be able to experience this: between the office and his spare time, there is a secret passage that easily separates the two from each other, but just as easily melds them together as well.

This passageway seems to be in line with what some sociologist once said: the road to survival in capitalism is a nervous breakdown. And to him, it was precisely this nervous breakdown that gave him a larger space for freedom than others had.

It would be just like him making love to two women at the same time.

Him: Airport 2

The airport was full of stranded passengers tonight. People came up with innovative ways to make space for sleep. He finally found a long bench which he could lie on. Despite closing his eyes, he could still sense the harsh ceiling lights shining onto his body, as if he was under a shadowless surgery lamp in an operating theater.

In his dazed state, he tried his utmost to count the number of days that he had already spent away from his wife. However his calculations were constantly interrupted by various vague disturbances, and her

rather hoarse voice began to seem increasingly more urgent, until he could distinctly make out what she said: I hate you.

How did he reply? He thought he tried defending himself: All my friends around me have problems too, and in comparison with them, you and I seem rather harmonious the way we are. He seemed to have been pleased with himself as he added: At least there'd never been another woman who'd gotten involved with me.

You only love yourself, and thereafter, she did not say another word.

It was after that argument (in fact, it would have been better if they had truly argued) that he thought viciously to himself: someday, I'm definitely going to disappear.

Now, as he slumped against the bench in utter exhaustion and remembered the look on her face as she spoke, he suddenly realized: when she talked about hate, her eyes flashed with a strange sparkle. Should he have pressed on and asked: Is that hate?

It would have been better if it was hate.

Her: Slaughter

She felt a sense of disgust, and could not bear having flesh entering her own body day after day.

Is this atrophy?

She thought of a line from a poem by a young writer:

A dog that is cut up into lumps is still called a dog. People who have overcome their fears and who still retain their sense of self-preservation are still people.

A Director's Notes

One of Eisenstein's greatest wishes when he was alive was to make a movie of Marx's *Das Kapital*. Yet today, the sort of piecemeal working process evident in Taylor-style video works has evolved into a system of self-evaluation that is even more exciting and attractive

(intellectuals work just like volunteers do, and their first challenge would be to achieve and realize their own self-worth). It would therefore be even more difficult to turn *Das Kapital* into a movie.

If we do a re-edit of the countless movies that have already been filmed (De Sica, Fellini, Godard, Ozu, Hou Hsiao-hsien), I reckon we could produce a new *Das Kapital*—***Das Kapital of the Senses***.

Her: Garden

Amidst the stench of the cement, she stood beside the sales agent, leaning down to peer at the garden. This portion of the building was its pride: colorful garbage bins in the shape of mushrooms were scattered around the space to evoke an atmosphere of a children's playground; the predominantly blue and green ceramic tiles on the bottom of the swimming pool formed an image of a dolphin. Residents strolled hand in hand as couples in the garden, just like how you would imagine a scene in a movie replete with sweetness, shot with a slow pan across the space. Dusk was approaching, and the skies had begun to darken significantly. The agent pushed open the roughly hewn front door eagerly for her as she continued with her recommendation of the place.

The expressway was not too far away from her, and on both sides of the road sat gigantic factories which were still illuminated within. She could see with exceptional clarity the workers busy with the machines, as if they were using their individual life forces to light up each and every one of the torches planted within that wilderness.

Him: Wife 2

Through the round porthole window, he could see travelers moving like herds towards the airport coach, their eyes narrowed as they squinted whilst bracing against the wind. The pallid countenance of that middle-aged lady from Shanghai seemed exceptionally sexy. The cement ground was streaked with scars, glistening like puddles with a

pale sheen in the light.

After the lengthy traveling stint, he had once again returned to the airport of his homeland, and was greeted headlong by a gigantic advertisement for China Telecom: We are all one family. China seems to be like an empty shell that is filled with catchphrases and signs, none of which translated into corresponding substance. It made him feel a conflicting combination of hollowness and richness.

He suddenly had a burning wish to see his wife at the airport to welcome him home.

Her: Child

She bumped into her by sheer coincidence at the bus station! She was pregnant and heavy with child, and no longer resembled the nimble and intelligent student she remembered from the past. She made small talk with her about events in her life. Just like a bear waking from hibernation through the winter, she could feel her entire being infused with a wondrous sense of generosity; it felt as if nothing in this world mattered to her, as if everyone who had worried about her or who was sympathetic towards her was just an idiot.

Together they reminisced about the high point of her life: how she, in all her radiance, had participated in the school ball; how she had naturally become the darling of all the boys; how her soft and shiny hair resembled a Head & Shoulders shampoo advertisement.

A scavenging old man pushing a cart remodeled from a bicycle passed them by. All his possessions were in the metal trolley tugged along behind him. He was clad in a multi-colored shirt and seemed to be in good health. As he walked by, he was mumbling to himself as if he was looking for something he had misplaced.

"If I am willing, I can spend my life with the person I love and my children anytime." As she gazed at the gentle, curved silhouette of the old man, she found her spirits lifted somewhat.

A Director's Notes

Perhaps he and she will never get to meet; perhaps he and she will always live together—in my outdoor film location.

As I scribbled all this down, I could see the future envisioned many years down the road, with a beautiful and sweetly fragrant dawn, and your sleepy eyes just waking up to the world—that moment is what happiness is:

You are eighteen
I am nineteen
We are still anonymous

Anonymous, and this is when the universe begins.

Acknowledgments

My deepest gratitude goes to all the people who have been supporting my writings, and in particular, Daniel Birnbaum, Michael Eddy, Gege, He Cong, Huang He, Melissa Lim, Kang He, Brian Kuan Wood, Mianmian, Hans Ulrich Obrist, Caroline Schneider, Anton Vidokle, Yang Fudong, and Zhang Wei, without whose enthusiasm, this book could not have been realized.

—Hu Fang

Hu Fang
Garden of Mirrored Flowers

Co-published by Sternberg Press and Vitamin Creative Space

Design: Huang He/Vitamin Creative Space
Proofreading: Michael Eddy and Kari Rittenbach
Translation: Melissa Lim

ISBN 978-1-934105-15-3

Vitamin Creative Space
Room 301, 29 Hao, Hengyijie, Chigangxilu
Guangzhou, 510300, China
www.vitamincreativespace.com

Sternberg Press
Caroline Schneider
Karl-Marx-Allee 78, D-10243 Berlin
1182 Broadway 1602, New York, NY 10001
www.sternberg-press.com

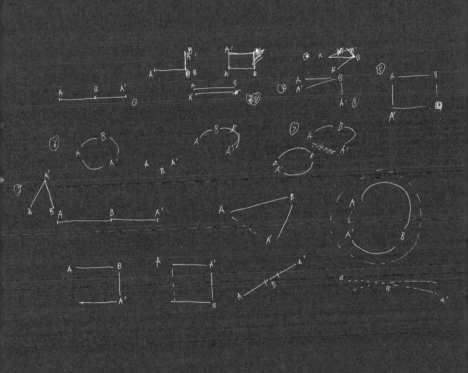